Geographical Interpretation through Photographs

(*and Interpretation of Statistics*)

by TAN KIM HOCK
Dip.Com., A.C.P., A.S.C.T., F.R.Econ.S.

and EWEN D. R. BROWN
M.A. (Hons).

LONDON GEORGE ALLEN & UNWIN LTD
Ruskin House Museum Street

FIRST PUBLISHED IN 1972

First published in 1972

ISBN 0 04 910048 3

This book is based on *Geographical Interpretation of Photographs, Statistical Diagrams and Data for School Certificate*, by Tan Kim Hock and Professor Anne Johnson, published by M.P.H. Publications Sd. Bhd., Singapore. We are grateful to Professor Johnson and M.P.H. Publications for allowing us to incorporate some of their book in our new publication.

Printed in Great Britain
in 10 pt Times Roman type
by Compton Printing Ltd
London and Aylesbury

Contents

Acknowledgements

The authors and publishers are grateful to the following for allowing the use of the various photographs in this book:
Aerofilms Ltd
Associated Biscuits Ltd
Australian News and Information Bureau
The British Petroleum Co. Ltd
Cadbury Brothers Ltd, Bournville
The Dole Company (Pineapples) Ltd, Honolulu, Hawaii
East African Railways and Harbours
Ford Motor Company, U.K.
I.H.I. Heavy Industries Ltd, Japan
International Harvester Export Co., Chicago, Illinois, U.S.A.
Jurong Shipyard, Singapore
Kenya High Commission and Kenya Tourist Office
National Film Board of Canada, Ottawa
Netherlands Embassy, Singapore, and K.L.M. Airlines
New Zealand Publicity
J. F. Osborne, Esq., and Tanzania Sisal Growers' Association
Swiss National Tourist Office, Zürich
and to J. Allan Cash for the remaining 19 illustrations.

Part One

Introduction for the Student:
Geographical Knowledge through Pictures

The best way to study geography is to travel round the world seeing, observing and examining various types of land forms and different aspects of agricultural and industrial activities—from the diverse crops grown as raw materials for industry or as food and clothing for man, to the widely different finishing processes in the numerous kinds of factories. Of course, it would be most interesting to carry out this method of studying geography at first-hand, but, unfortunately, very few of us have the financial resources, or even the time, to do so.

The next best and most practical way of studying geography is by a careful examination of photographs sufficiently panoramic to cover a wide range of geographical features, agricultural and industrial activities, and so on. These photographs are found not only in textbooks such as this one; magazines, newspapers, television programmes, advertisements, cinema shows, picture displays, in fact *any* medium or agency which shows *any* representation of real life is useful to the geography student *because* he or she is trained to examine life as it exists on our Earth. The purpose of this book is twofold:

1. To present a variety of pictures and statistics and to advise the student how to extract most information from them.
2. To present an attractive form of geographical information which will be useful in passing the Certificate Examination.

HOW TO EXAMINE A PHOTOGRAPH OR PICTURE

Pictures may be divided into two categories:

(a) General views of a large area; and
(b) Particular views usually concentrating or focusing on one item fairly close to the camera.

(a) *General Views*

This type of picture is most often used to test recognition of physical landscape. It is customary, and usually easiest, to divide the picture into areas: for instance, foreground, middle distance, background; or, left, centre,

and right. These divisions may not always be exact, for instance on page 32 the sub-divisions would be as follows:

1. Foreground with houses.
2. Middle distance–valley.
3. Background of mountains

and, again, on page 70 there is no background, only a foreground (with a large sisal plant) and a middle distance (a sisal plantation). The student is at liberty to divide the picture any way he or she chooses; the only 'rule' is that the whole area must be thoroughly examined. Once the sub-divisions are made, the landscape can be conveniently classified under any one of these categories:

1. *Natural*, i.e. various types of landforms, for example volcanoes, plateaux, glacial erosion, weathering by rains, moraines, screes, ribbon lakes, river valleys, fiord coasts, scenes of erosion by pounding waves, wind and running water, ox-bow lakes and meanders, etc.

2. *Agricultural*, i.e. different kinds of farming, for example the cultivation of cereals (whether intensively or extensively), fibres, beverages, nuts, fruits (tropical, citrus and deciduous), vegetable cultivation (market gardening), dairy farming, mixed farming and cattle ranching.

3. *Industrial*, i.e. factories within a manufacturing complex. Much depends on the appearance of the buildings or the form of structural steelwork. Tall, fractionating columns or towers and a maze of pipes

with large tanks in the distance indicate an oil refinery, whereas a vast area of desolate land studded with derricks means only an oil-field in which mineral oil is mined. A large building with a few tall chimneys billowing black smoke may possibly suggest a thermal power station. Such a power station may be situated near a port, or close to a coal field, or at a short distance from a city. Unlike a a hydroelectric power station, a thermal power station is seldom located in rugged, mountainous regions, for obvious reasons. There are, however, no hard and fast rules for pinning down any particular industry, especially an unfamiliar one, but much can be learnt from examining the photographic illustrations in your textbooks and read-ing carefully what the captions tell about them. In this way, a broader acquaintance with photographs of different types of industries is obtained.

4. *Exploitation* of natural resources. These activities can be sub-divided into:

 (i) mining of oil and coal;
 (ii) mining of metallic minerals;
 (iii) mining of non-metallic minerals;
 (iv) lumbering in tropical and in coniferous forests;
 (v) the harnessing of water, natural gas, and geothermal steam.

5. *Settlement Pattern.* Buildings, either in their perspective or together with their surrounding areas, may provide clues as to whether the scene is a modern city, a village, a trading post, an isolated mining or smelting community; a coastal town, or a fishing port; or perhaps even a village by the side of a river.

 The presence of skyscrapers, wide roads and broad (or long) bridges possibly indicates a sophisticated community—or the capital city of a country, whereas farming will reflect arable pursuits, and farming equipment may perhaps be visible. There may perhaps be a few huts near the rice fields. On the other hand, a solitary building may be situated amidst a sea of grass which is, in fact, a cereal. And the only building in this case is most likely to be a silo or a grain elevator, rather than a farmer's house. But a building fenced off from a field in which cattle are grazing may well be the farmer's home.

(b) *Particular Views*

In this case attention is drawn to one special item; the questions asked will be concerned with the detailed knowledge of that item; and may even

test the student's knowledge of the subject outside what is shown on the photograph. For instance on page 94 attention is focused on the mechanized picking of pineapples, and direct questions could be asked about what is happening; in addition, questions might well be asked on the climate necessary for production, areas of production, meaning of plantation agriculture, etc. Summing up so far, then, students are expected, and indeed advised, to:

(i) examine the evidence shown in the picture in a logical and thorough fashion; and

(ii) consider the facts about the subject not shown in the picture, as this will assist revision of the topic.

TWO WORKED EXAMPLES, ONE GENERAL AND ONE PARTICULAR

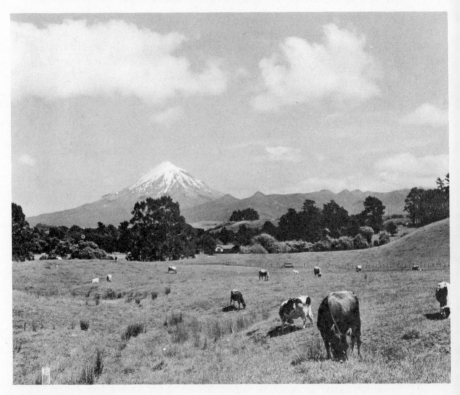

Question

Examine this picture carefully and then:

(a) Describe the physical landscape.

(b) Describe the climatic conditions in this area.

(c) What type of farming is taking place? Give full reasons for your answer.

Answers

(a) This picture may be divided into three parts: the background, which consists of the mountain; the middle distance, from the foot of the mountain to the front edge of the trees; and the foreground from the edge of the trees to the foot of the picture.

Background. This is composed of one major physical feature, namely the mountain. It is cone-shaped and is an extinct volcano. It is several thousand feet high, estimated from its base to the snow-capped summit. This snow cap is incomplete which suggests dissection in the form of gullies.

Middle. Not much can be seen in this area. However, immediately to the right of the base of the mountain can be seen a series of small conelets outlined on the horizon—they may be subsidiary cones of the large mountain. From these cones towards the foreground the land drops gently and appears to be undulating.

Foreground. This is gently undulating. It rises and falls no more than 50 to 100 feet. The general slope seems to be rising to the right.

(b) NOTE first of all: Climatic evidence may be got from the following items: natural vegetation; animals, such as elephants, polar bears, etc.; crops growing in fields; clothes worn by people; appearance of people (their skin colour etc.); shadows cast by the sun (a low or high angle?); buildings and building material to some extent; possibly cloud and sky conditions; types of erosion by wind, water or ice. These will never all be seen on any one picture, but there are usually a sufficient number present to enable an accurate conclusion to be reached.

In this picture there are two major items which help to determine the climate. They are vegetation and animals.

The vegetation is mixed deciduous and coniferous trees (conifers on the right), and grassland. The grass is not cultivated, that is, it has *not* been planted by man—the evidence is that the grass is not all the same variety or type, and there are tufts of reedy-looking grass (suggesting damp, moist conditions on the ground). This combination of vegetation exists in areas where temperatures are cool temperate.

The animals are cattle—either dairy cattle kept for their milk, or beef cattle being fattened. In either case they are on pastureland which means,

firstly that the rainfall is adequate for this purpose and secondly that the rainfall is regular throughout the year.

Thus temperature and rainfall conditions point to a cool temperate oceanic location.

(c) The occupation is dairy-farming. The cattle are well-looked after—they are well-fed and plump and they have glossy shining hides. Secondly, they are fenced in and are not crowded; they have plenty of space in which to graze or feed. Thirdly, they are close to what appear to be the farm buildings, which makes it easy to 'take them in' for milking twice a day.

NOTE
1. As regards temperature, look for evidence which can locate a picture within the four broad latitudinal divisions of cold, cool, warm, hot.
2. As regards rainfall, look for evidence which can tell you about the total (plenty, medium or scanty,) and the distribution (regular or seasonal).
3. Do not use compass direction unless you can *prove* direction from the photograph—use the expressions 'top, bottom, left, right'.
4. Use both direct and indirect evidence.
5. Be relevant.

Questions

These photographs show two kinds of docks.
1. Name the docks in the first and second pictures respectively.
2. Explain the advantages and disadvantages of each type of dock.
3. Can the presence and availability of docks for ship repairs be considered as a necessary and integral part of port facilities? If so, why?
4. Apart from ship repairs, name one other dockyard service to ships.
5. Explain the term shipyard. What is its primary function?
6. Is the ship in the second picture undergoing repairs? If not, state your reasons based on clues from the photograph. What buildings are those behind the dock?
7. How do you identify the type of vessel in the second picture?
8. GENERAL: Industries can be classified as light or heavy. How would you place the ship-building industry? On what grounds do you arrive at your decision?
9. GENERAL: Countries can be classified as (a) advanced, (b) developing, or (c) under-developed, depending on their stage of technological attainment. When a country is building ships each up to 25,000 tons for export, how would you classify such a country?
10. Draw up a list of the major ship-building countries of the world.

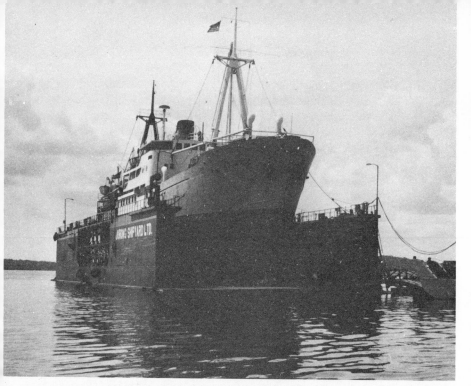

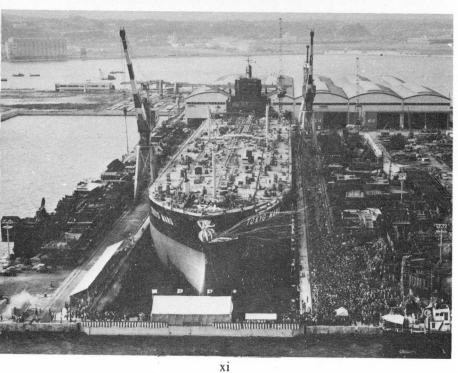

11. What geographical factors encourage prosperous ship-building?
12. Why do the operators of ship-repairing docks fix a strict schedule for each ship needing repairs and adhere rigidly to that schedule?

Answers

1. The docks are (a) floating at the top; (b) dry dock at the bottom.
2. The advantages of the floating dock are: firstly, the dock can be moved to the ship which can be anywhere in reasonably quiet waters such as an estuary; secondly, a floating dock is relatively inexpensive to build and operate; thirdly, it saves time in comparison to using a dry dock. The main disadvantage is that the range of operations which can be done from it is limited; the bottom of the boat cannot be repaired as it is still floating. A dry dock has the big advantage of enabling *all* repairs to be done, including repairs of possible damage to the bottom of the ship as well as cleaning. Weather and sea conditions do not matter at all because the dry dock is completely cut off from the water. It is expensive to run and maintain.
3. Yes, because ships quite frequently suffer damage from rough weather conditions when at sea.
4. Supplying fuel (diesel oil or coal).
5. A shipyard is a place where ships are built. It is always located close to the water (either sea or inland lake). The primary function is shipbuilding—but repairs can be done and also shipbreaking, namely the complete dismantling of an old ship.
6. Judging from the crowds of people on the right of the ship, and the flags flying from the large tent near the front of the ship, this is a launching ceremony. The vessel is not undergoing repairs. The buildings are large storage sheds or warehouses.
7. It is an oil tanker. At the back, or stern (furthest from the camera) is the captain's bridge and all the rooms and offices; the rest of the ship has little or no superstructure, or cranes for lifting cargo, etc. The oil is pumped into and out of huge tanks inside the body of the ship.
8. The shipbuilding industry is classified as 'heavy'. Today this term means that the heavy industry produces one very large item at a time; it may take over a year for all the shipyard workers to produce one ship. (Light industries produce many of the same items at a time, e.g. refrigerators, motor-cars, electric light bulbs.)
9. If a country is capable of building and exporting ships of up to 25,000 tons each, it will have an advanced classification.

10. (i) Japan (iv) U.K.
 (ii) W. Germany (v) Norway
 (iii) Sweden (vi) France.
11. Factors encouraging prosperous shipbuilding are:
 (a) Plentiful local supplies of the essentials for making iron and
 steel, namely iron ore, coking coal, and skilled labour.
 (b) A coastline with estuaries, or rias, offering sheltered water.
 (c) A maritime nation, namely one which uses the sea a great deal.
12. Ships requiring repairs notify the dock operators as far in advance
 as possible so that space in the docks will be reserved for their
 arrival. Then the dock operators can and do prepare a work time-
 table or schedule for each ship. If they cannot adhere to this, there
 will be confusion and congestion of ships waiting to get in.

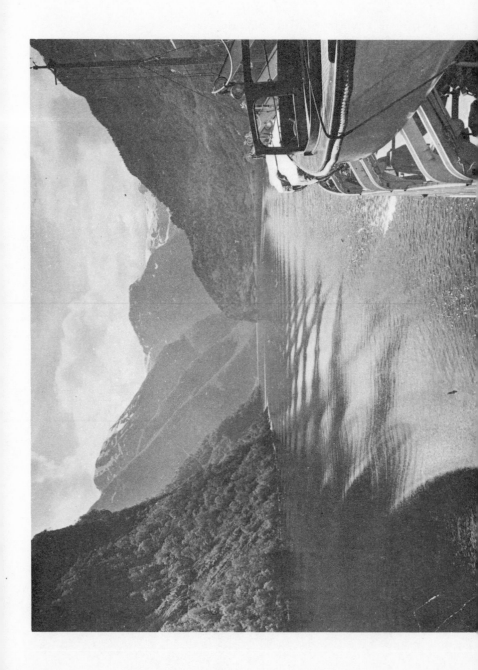

Exercises in Interpreting Geographical Photographs

1. Physical

1

1. What is the name given to this water feature?

2. How was it formed?

3. Name three areas in the world where this feature is common.

4. List the advantages and disadvantages of this feature to man (concentrate on the economic and communications aspects).

5. In what ways can the vegetation and the snow on the mountain tops help to determine the climate of this area?

6. If this feature had no water in it, what would a cross-section of it reveal?

7. In relation to the camera, in which direction is the boat travelling?

8. The mountain tops appear to be approximately the same height. What kind of mountains are they?

9. Is there any evidence of erosion? If so, where and by what means?

10. Examine the cloud formations and say what weather conditions are likely.

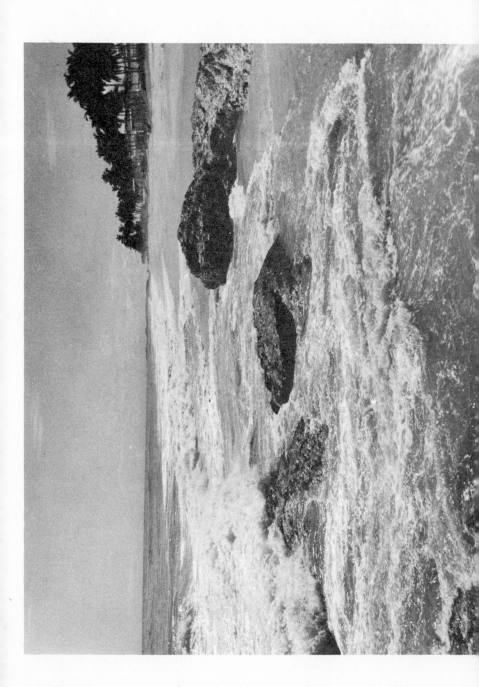

2

1. What is a wave?

2. Why does some of the water appear white?

3. What happens when a wave meets the shore-line?

4. Why are the rocks in the foreground not smooth and rounded?

5. This type of coast-line is very common in Africa:
 (a) Name three economic advantages gained from it.
 (b) Discuss the disadvantages as regards ports and harbours; and examine how man has overcome them.

6. Approximately what is the distance covered by a wave in the picture from where it begins to break to where it ends?

7. Apart from this type of coast-line, name three other types.

8. Draw diagrams to illustrate the work of the sea on a cliff.

9. What is longshore drift? How can its effects on a shingle beach be controlled?

10. Using diagrams, explain the following terms:
 spit, bar, lagoon, headland, bay.

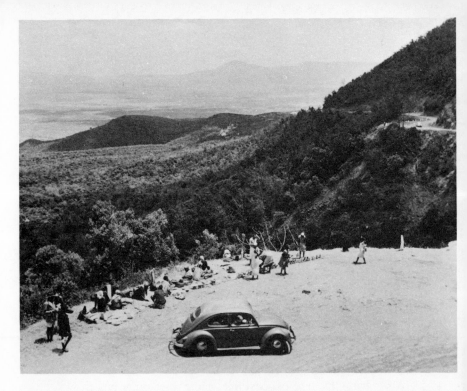

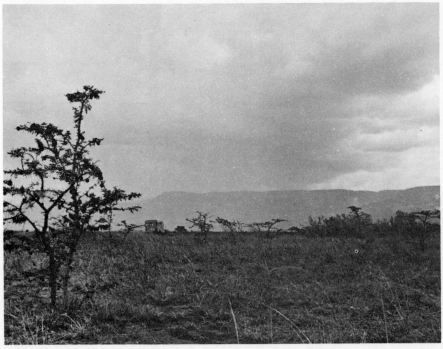

4

3

These two photographs are different views of the same major African physical feature. Name the feature and state its extent and location in Africa. (Hint: the word major refers to length—it extends outside the continent.)

TOP

1. Describe the general view.

2. Why does the road have several bends in the short stretch visible?

3. Describe the problems presented by this type of feature to communications.

4. Apart from the car driver what are the people doing, and why did they choose this place?

5. The natural vegetation is forest; but towards the top of the picture the forest ends. Give reasons for this.

6. Draw diagrams to show how this type of feature was formed.

7. Write down any differences between your diagram (and/or a similar one in a textbook) and the actual picture here.

BOTTOM

1. This photograph was taken from a different part of the same feature. Describe the appearance of the background.

2. Briefly describe the foreground.

3. Why is there no middle distance?

4. Contrast the vegetation with that in the top picture and give reasons.

5. What farming type is likely to take place? Give reasons.

6. Describe the probable weather conditions.

7. Why might this feature be a tourist attraction?

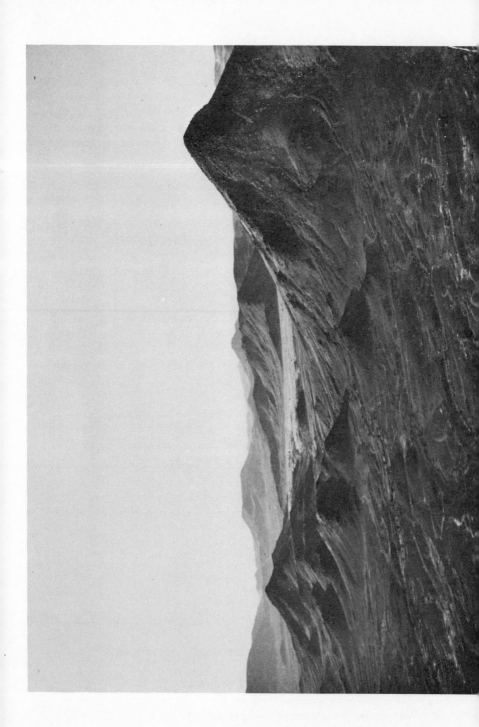

4

1. Describe and account for the physical features in this photograph.

2. Examine in detail the large hill in the right centre of the photograph (mention height, slope, shape, dissection).

3. Consider the foreground closely and then describe the natural vegetation.

4. Evidence as regards settlement is difficult to find, but there is some. Why is the settlement so very scattered?

5. In an area such as this is it normal to find relatively sparse settlement? State your reasons whether your answer is yes or no.

6. Name four other parts of the world where this type of landscape is common.

7. Draw diagrams to show how a physical feature, such as that in question 2, is formed.

8. Explain the terms dormant, extinct and active in connection with volcanoes.

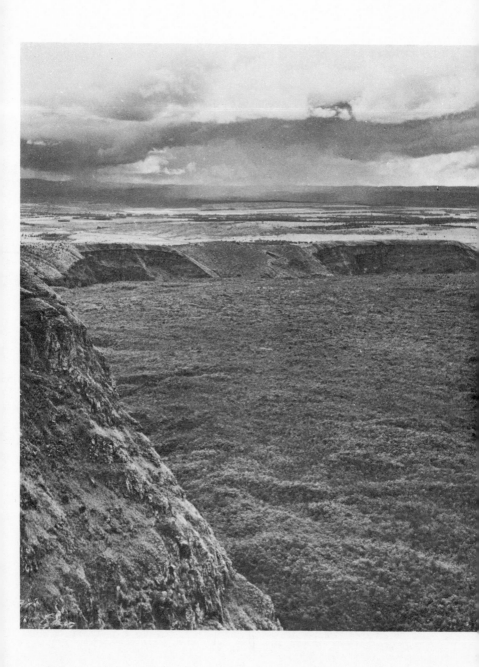

5

This picture shows a different aspect of volcanic features.

1. What name is given to the main feature in the foreground?

2. Describe the appearance of the middle distance and background.

3. There are also other volcanic features—name them.

4. Draw diagrams to show how these two features are normally formed (hint: one is a plateau, the other a plain.)

5. Say what you can about the natural vegetation in the foreground and middle distance.

6. Describe the likely weather conditions.

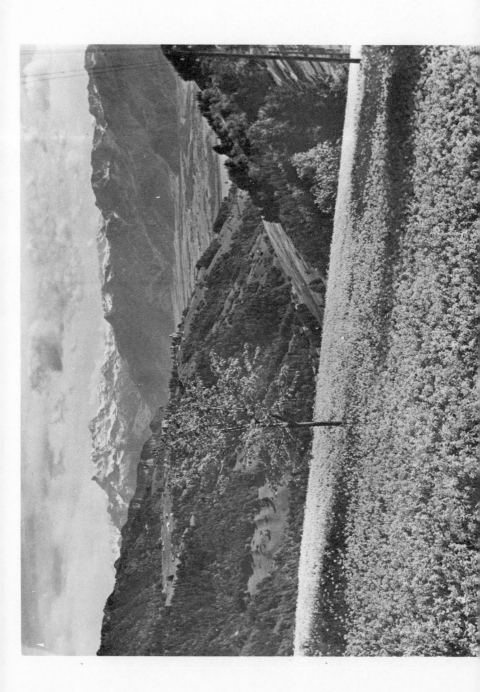

6

1. This picture was taken in a part of Europe. Attempt to give a general location and state your reasons.

2. Name the regions in three other continents where similar views can be seen.

3. Describe the background under the following paragraph headings: (a) Formation, (b) Present appearance, (c) Erosion, (d) Advantages and disadvantages to man.

4. Assuming the foreground is at its highest altitude where the camera was, then we may say it is a different kind of mountain system from that in the background. Name it, and draw diagrams to show how it was formed (hint: use blocks).

5. Describe the natural vegetation.

6. What type of farming takes place here and why?

7. What are the wires on poles at the right side of the picture?

8. In what season of the year was the picture taken? State your evidence in full.

9. There are two large buildings with very different shapes near each other at the edge of the middle distance. What might they be and why were they built there?

10. What are the main sources of fuel and power in an area like this?

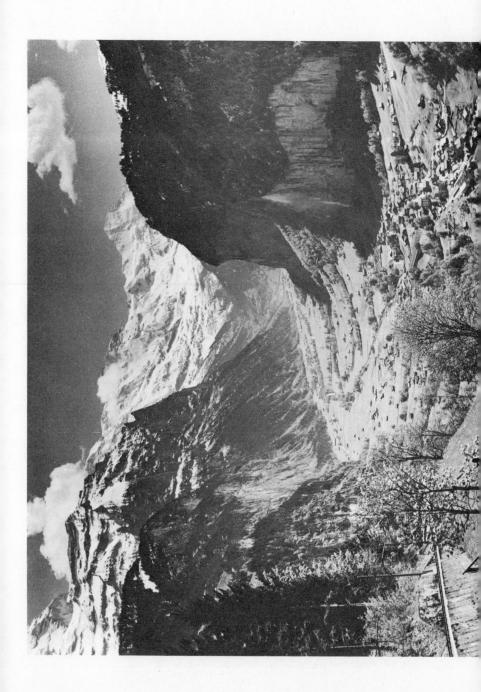

7

This photograph gives a more detailed picture of a scene in a similar situation to the previous picture.

1. In what season of the year was the picture taken?

2. What is the main means of communication *down* the valley?

3. What other means of communication is shown and how does it operate?

4. Why have most of the buildings got sloping roofs?

5. The village is fairly large. What are the likely occupations of the people?

6. Why is there still snow on the mountains when the sun is shining on them?

7. Are the clouds likely to give rain? Give reasons for your answer.

8. Name, specifically, the type of vegetation on the mountain sides.

9. What are the uses of this type of vegetation?

10. Why are the sides of the valley so steep?

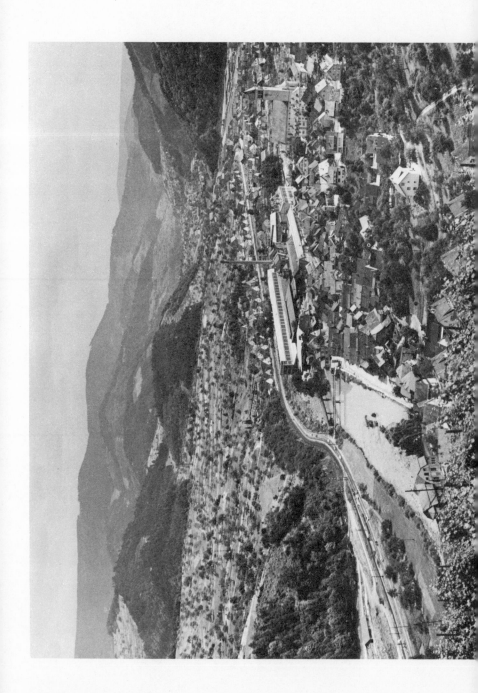

14

8

This picture was taken in Europe.

1. Describe the mountains in the background, paying attention to: (a) top surfaces, (b) slopes, (c) erosion.

2. Name the type of mountain (block, folded, volcanic, residual).

3. The river is a right bank tributary of the Rhine. Where approximately was the photograph taken?

4. What is the crop growing in the immediate foreground?

5. In what season of the year was the photograph taken?

6. Give a term to the way settlement has been built on the far side of the road. Give reasons for your answer.

7. Has there been much rain recently? Give evidence.

8. What is the land utilization between the far side of the road and the edge of the mountains?

9. In the middle of the foreground is a large factory, Name several likely products.

10. What evidence is there that this area has been glaciated?

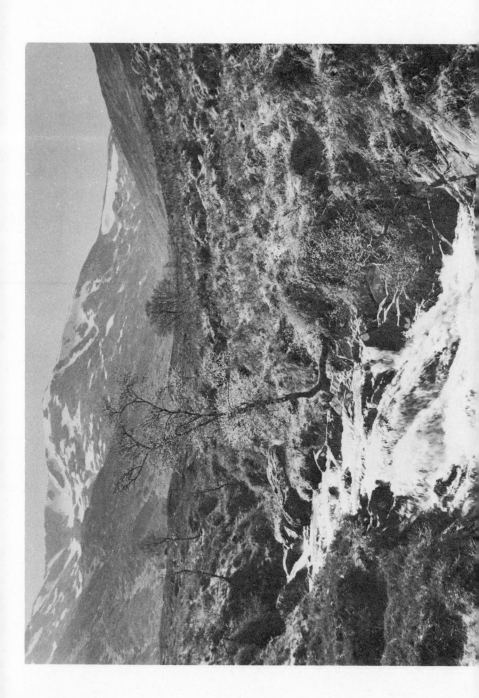

9

1. State evidence that this river is eroding both downwards and sideways.

2. What does the term 'tools of a river' mean? Are there any in this picture?

3. Describe the vegetation in the foreground.

4. Why is the vegetation not more dense and lush?

5. Is this area easy to farm? Give reasons.

6. If it was farmed what type of farming would take place?

7. The latitude of this place is about 57 degrees North. Why is the direction (north or south) a slope is facing so important here? What difference does it make to the vegetation?

8. Apart from drinking water, could this river have any use? If so, what?

9. The longitude of this place is about $3\frac{1}{2}$ degrees West of Greenwich. In which country was the picture taken?

10. Give reasons (about six) why there is no settlement, no sign of communication or occupation, in this area.

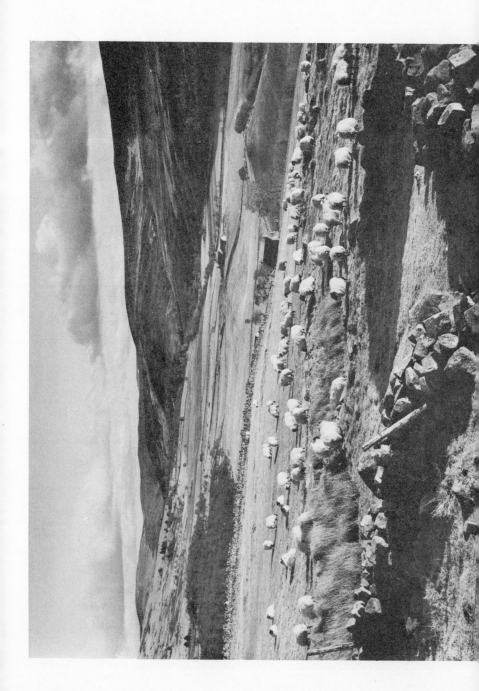

10

1. Describe the general view from the physical aspect.

2. Why is there not much settlement?

3. State evidence which shows this area has been glaciated.

4. What type of farming is being carried out?

5. In the immediate foreground are rocks. What are they used for and why?

6. Give a reasoned assessment of the type of climate.

7. Examine the shadows. The latitude is about 58 degrees North. This picture was taken in the early afternoon. Now establish direction, namely north, south, east and west.

8. These animals are kept mainly for their wool. What must be done to the wool before it is ready for making into a garment?

9. Which countries produce most of the world's wool?

10. Which countries import wool or woollen goods and why?

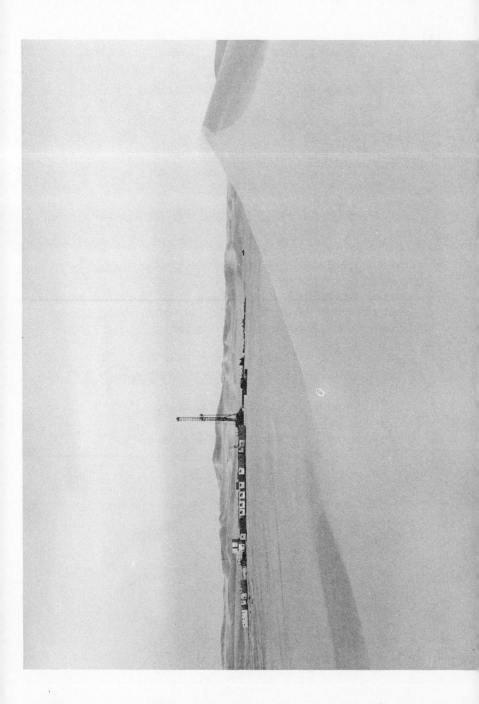

11

1. Name the features shown in this picture and describe the general appearance of the land.

2. What is the land form on the right foreground of the picture called?

3. Is this land form permanent or temporary? Give your reasons.

4. Draw a block diagram and add explanatory notes to show how the land form in the foreground has been formed.

5. The following features are associated with hot deserts—simoon, sandstorms, barkhan. Write brief notes on each of them. Where applicable, illustrate your answer with a sketch.

6. In the area shown in the picture, there are both local and foreign people living. Suggest a means whereby they can get water, food and provisions.

7. How do the people earn a living in this particular area?

8. Why do the hot deserts have very few or no people living in them? Why has the presence of mineral wealth in most cases changed this?

9. What is the tall steel structure in the background called? What is it used for?

10. After it has been extracted, how is the product transported?

11. Briefly set out the geological conditions under which this product is formed. Draw a diagram to illustrate your answer.

12. Suggest a likely locality in Africa where a picture like this one could be taken.

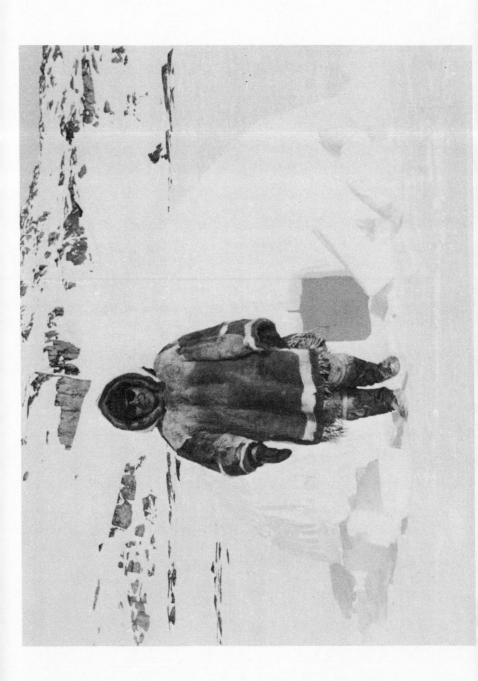

12

1. What is the type of dwelling behind the man called?

2. What is it made of? Does he live in it all the year round?

3. What was the weather like when this picture was taken? Give evidence from the photograph.

4. Briefly describe the precipitation and temperature patterns of this region in summer.

5. Why are agricultural pursuits impossible in such a region?

6. Suggest ways in which the Eskimo may normally earn a living.

7. How does the Eskimo keep himself warm in his house?

8. Name two countries, and if possible locate the latitude, where Eskimos are living at present.

9. Do you expect a high, or a low, standard of living in the life of an Eskimo? Give your reasons.

10. How do the Eskimos move their belongings about? What form of transport do they usually use? Describe any kind of transport you know of that the Eskimo may use.

11. What is a summer tent? What material is it usually made of? Do you think the Eskimo would live in a summer tent for most of the year? Give your reasons.

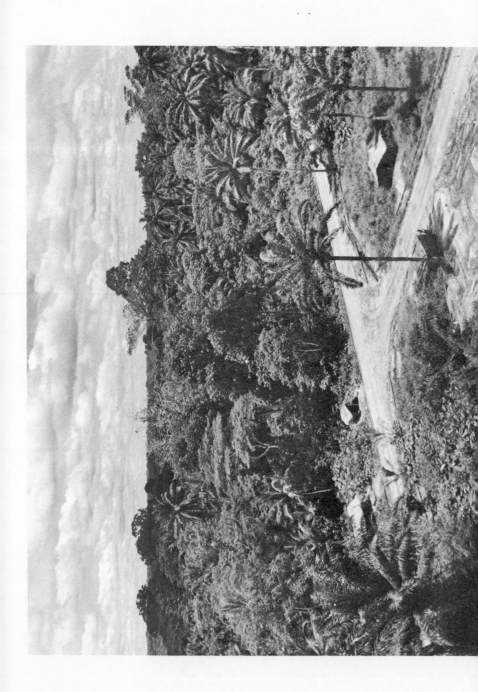

2. Vegetation

13

1. Name this type of natural vegetation.

2. List the difficulties in establishing communications through such vegetation.

3. Find out what 'natural regeneration' means as applied to trees.

4. What are the economic uses of such vegetation?

5. What difficulties are met in obtaining the benefit of these economic uses?

6. What is meant by 'three horizons' in such vegetation? Can they be seen here?

7. What might the long poles be used for which are lying on the ground at the road junction?

8. What kind of palm trees are seen in the photograph?

9. Name two other types of palm tree.

10. Locate on a world map the principal areas of the world which have vegetation like this.

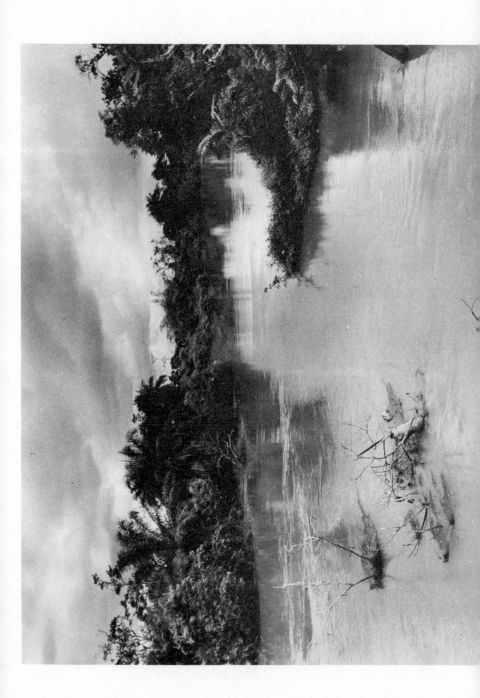

14

1. Is the water likely to taste bitter, or sweet, or tasteless?

2. This picture was taken in Nigeria. Name a likely location and give reasons for your choice.

3. What is the best means of communication in an area like this and why?

4. What economic uses has this area?

5. At what season of the year might this picture have been taken?

6. Is there a current in the water? If so which way is it flowing?

7. State the disadvantages (for habitation and transport) of such an area.

8. What likely future source of fuel is being created by nature in this area? Give evidence.

9. Is settlement attracted to or repelled from this area?

10. Under what circumstances might settlement definitely be established here?

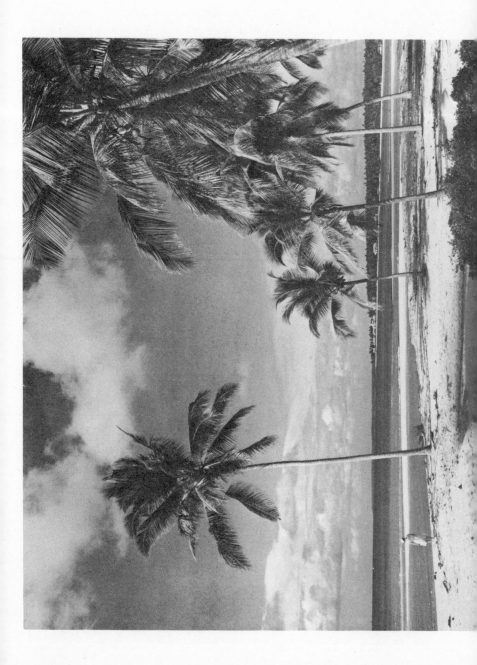

15

1. What type of palm trees are shown in the picture?

2. It has been said that every part of this type of palm can be used. Take one tree from the roots to the leaves and state what uses the various parts could have.

3. Are these trees natural growth or did man plant them? Give reasons.

4. Apart from fishing, what kind of activity might an African country promote on a beach such as this?

5. How could this be carried out?

6. From which parts of the world would people come to take part in this activity?

7. Why would they do so?

8. In the land background is dense vegetation. What kind is it and what are its uses?

9. This picture was taken in the early afternoon. Give a reasoned statement for the approximate latitude.

10. Where else in Africa will beaches like this be found?

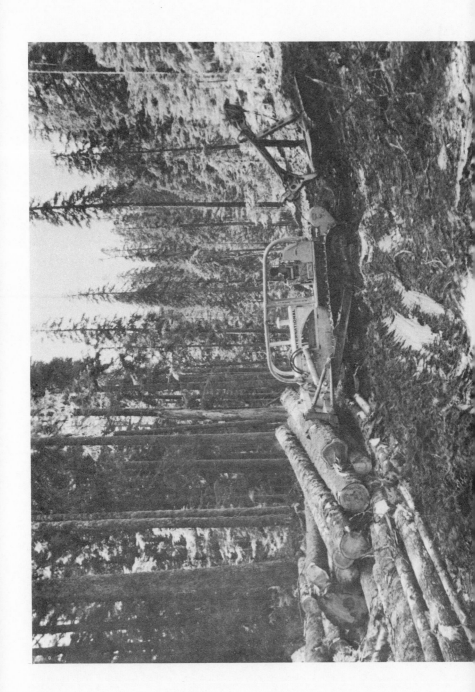

16

1. Name the economic activity that is being carried out in the forest. In which season does this activity take place, and why is this so?

2. What do you call the machine in the picture? Is it used for pushing the logs only?

3. Name a few kinds of this type of tree that are valuable, stating the particular purposes for which each species is ideally suited.

4. State the type of trees shown in the picture, giving reasons for your identification.

5. Are trees of this type mostly found growing together in one place, or are they widely dispersed among other species?

6. Name three distinct advantages that the trees in this forest have over those in the Equatorial Rain Forest.

7. What shape are the leaves of the trees in this picture?

8. The floor of this type of forest is usually without secondary growth. Why is this so?

9. Suggest two different ways by which the logs can be conveyed to the mills.

10. Name six countries, north of the Equator, where forests of this type exist.

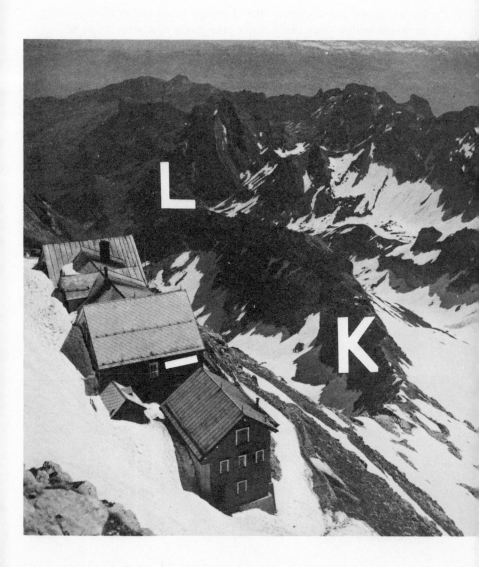

17

1. Name the physical feature indicated by LK.
2. What particular aspect of weathering produces the sharp-edged, jagged outlines of the peaks?
3. Give reasons to suggest whether the snowfall has been heavy.
4. How would you account for the presence of the buildings in such a mountainous setting?
5. Are the buildings located at the foot of a mountain pass, or at the top of it? Suggest a reason to support your answer.
6. Name a location where this picture might have been taken.
7. On the slope behind the first and second houses are scattered heaps of superficial deposits. What are such deposits known as? How are such deposits formed?
8. Mountains can be roughly divided into four kinds, namely (a) block mountains, (b) fold mountains, (c) residual mountains, and (d) volcanic mountains. To which kind do those mountains shown in this photograph belong?
9. Name a mountain (a different one must be chosen for each) which is well-known for:
 (a) being a greatly effective climate barrier.
 (b) being a boundary separating two nations (give two examples).
 (c) being regarded as sacred by the inhabitants of a certain country.
 (d) having the present remains of an extinct volcano.
 (e) being periodically an active volcano.
 (f) having the favourable factors for a vast hydroelectric scheme.
 (g) having an abundance of mineral wealth and near whose site there exists a greatly advanced industrial complex.
 (h) being the world's youngest mountain.
 (i) having the world's highest lake.
 (j) having a volcanic lake.
 (k) having the highest plateau on its northern slope.
 (l) being a popular resort for skiers and mountaineers.
 (m) forming the world's longest mountain chain (in an unbroken series of ranges).
 (n) having the world's longest tunnel underneath it.
 (o) having the world's highest waterfall, which falls in three leaps.
 (p) having within it a great region of inland drainage.
 (q) having ranges that radiate from its core.
10. Write a geographical essay on 'The Economic and Recreational Uses of Mountains'.

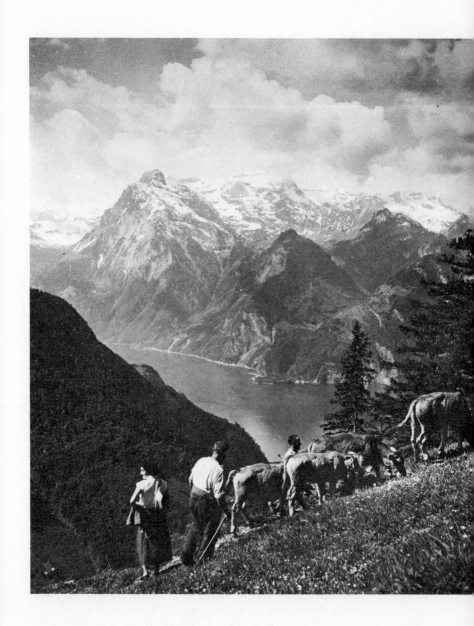

18

1. What are the people doing, and why must they accompany the cattle?

2. What is this process of moving along with the cattle called?

3. Name one or two countries where this process of moving along with the cattle is practised. In what time, or season, of the year does it take place?

4. Give two names by which mountain pastures, like those shown in the picture, are called.

5. Name two other dairy products, besides milk, that are associated with alpine cattle.

6. This picture was taken at an altitude of 4,500 feet above sea level. Would you say that the vegetation suggests the type of climate there? If so, identify the type of climate.

7. Of what probable origin could the lake be? (Suggest one possible way in which such a lake could have been formed).

8. Are the mountains block mountains or fold mountains?

9. Suggest a likely location (naming the country) in which this picture could have been taken.

10. Describe the mode of life of the people and show how it is influenced by geographical conditions.

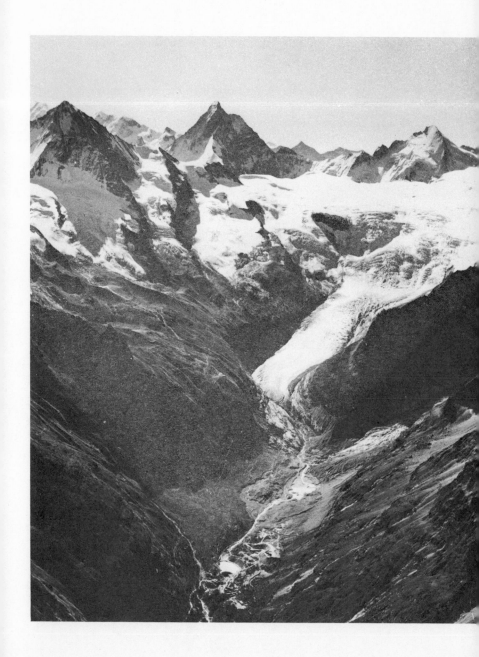

19

The photograph shows a glacier in Switzerland.

1. Mark an example of a pyramidal peak.

2. Can you indicate an example of a hanging valley and of an ice fall in this photograph?

3. Mark precisely the point where the glacier ends.

4. Situated in the background is the famous Matterhorn. Write M on the Matterhorn, and state whether its base is triangular or quadrilateral in shape.

5. Mark (a) the snow field and (b) the valley glacier.

6. Can you find an arete in this photograph? If so, mark A on it.

7. As a valley glacier moves along, two destructive processes of alteration are involved. Name these processes:

 (a) _____

 (b) _____

8. Draw an annotated sketch-section or a sketch to show the chief features of the landscape in this photograph.

9. In not more than ten lines, briefly describe some of the features of the glaciated area in this photograph.

10. Moraines are glacial deposits. How many kinds of moraines are there? Name them.

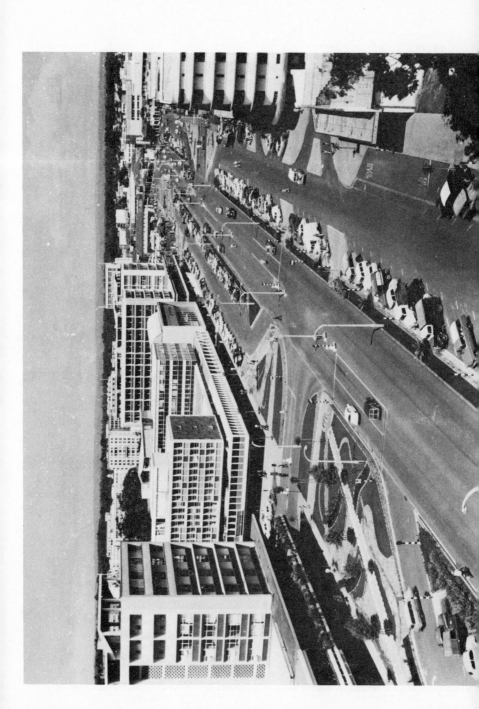

3. Human

20

This picture was taken in 1961; some buildings have been added since then, but the character of this part of the city (an East African capital) is the same today (1971).

1. What function does this part of the city have (settlement, industry, recreational, or commerce and business)?

2. Is there public transport in this city? Give reasons.

3. What is the purpose of the white lines on the roads?

4. What evidence is there that the volume of road traffic is often much greater than it is in the picture?

5. At what times of the day will the traffic volume increase?

6. How many motor-cars can you identify?

7. What are the tall, thin, curved pillars for on either side of the main road?

8. Why do some of the buildings have verandas?

9. What attempts have been made to beautify this part of the city?

10. What contributions can an ordinary citizen make to help keep his village, town or city clean?

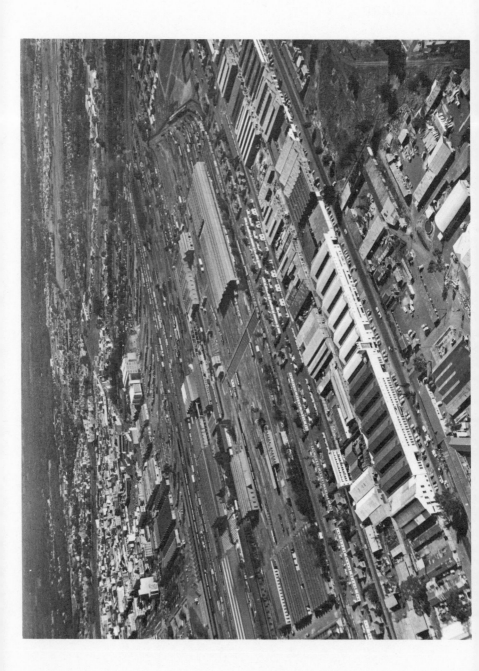

40

21

This is another part of the same city as in the previous picture.

1. What function does this part of the city have (settlement, industry, recreational, or commerce and business)?

2. What means of transport carries goods to and from the Gailey and Roberts buildings in the foreground?

3. What is the purpose of these buildings?

4. Opposite the main entrance to Gailey and Roberts is a compound with a circular container. What does the container hold and what is it used for?

5. In the middle distance are railway lines with very long sheds. What are these sheds for?

6. There is evidence of lineal settlement in the foreground. Find it and give an opinion about who will live there.

7. Apart from the *main* railway lines there are several short lines (called sidings), leading *from* the main lines. Where are these short lines going and why?

8. Find some suburbs of the main part of the city.

9. What is a suburb, and what is its main function?

10. Why is it advisable to keep the industrial part of a city separated from the main part? Make a list of your reasons.

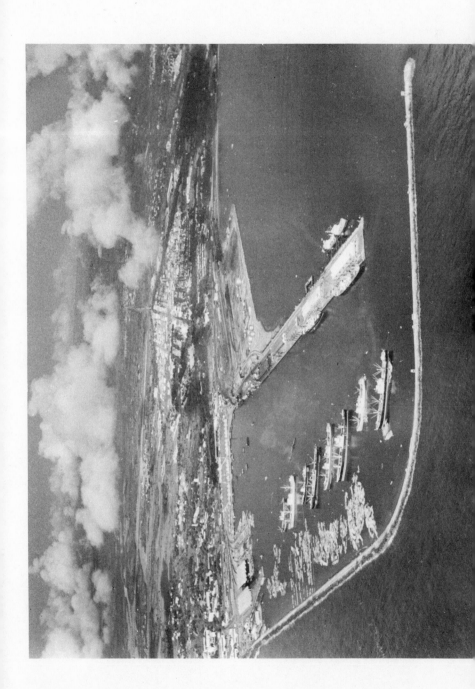

22

This picture was taken in 1962.

1. Why is it necessary to have breakwaters?

2. This port was artificially created in a West African country in 1928. Why should it have been necessary to do so? Give full reasons.

3. Draw a diagram to illustrate the following dock facilities: railway lines, storage warehouses, oil storage tanks, commercial houses.

4. In the middle distance is a town. How can you tell it was deliberately planned as opposed to developing through natural growth?

5. Why should communications to and from the port be easy?

6. What is lying on the water between the line of ships and the breakwater?

7. How did it get there?

8. Is there any need for tugs here? Give your reasons.

9. Is there any need for a dredger here? Give your reasons. (*Note:* a dredger is a boat which works in a port and scoops up mud and alluvium deposited in the docking area.)

10. Draw a map of the town and plot the suburban areas shown in the picture.

11. Why are the oil storage tanks on a separate (north) part of the docking area? (*Note:* north is to the right, south is to the left, west is at the top and east is at the foot of the photograph.)

12. Is there any difference in the water level between the south and north sides of the southern breakwater?

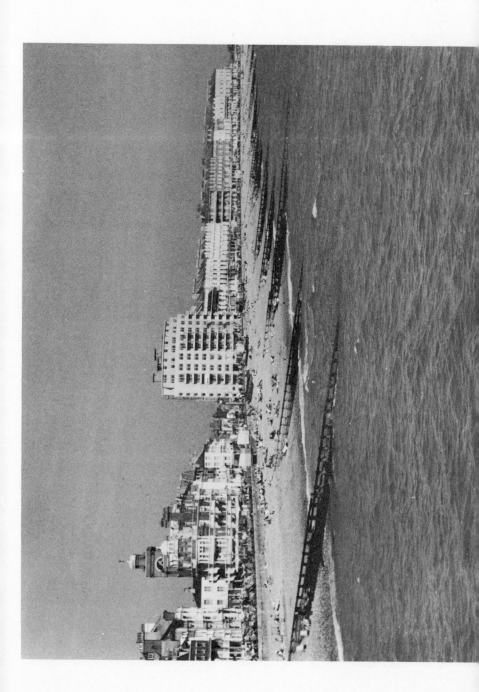

23

This is a town on the south coast of England.

1. What are the people doing?

2. Why are they doing it here and not at home?

3. What is the purpose of the wall at the top of the beach?

4. From which direction are the waves coming?

5. What are the groynes for? Explain fully, using diagrams.

6. Hotels are not the only places for temporary accommodation. Motels, caravan sites, bed and breakfast rooms, camping sites are alternative means. Find out what they are.

7. Is this an old or new part of the town?

8. Holiday resorts serve a very definite function in the life of any nation. For whom and why does this function exist?

9. What attractions are there in a holiday resort situated in a rural area?

10. Where, in your country, would you go for a holiday, apart from visits to see friends?

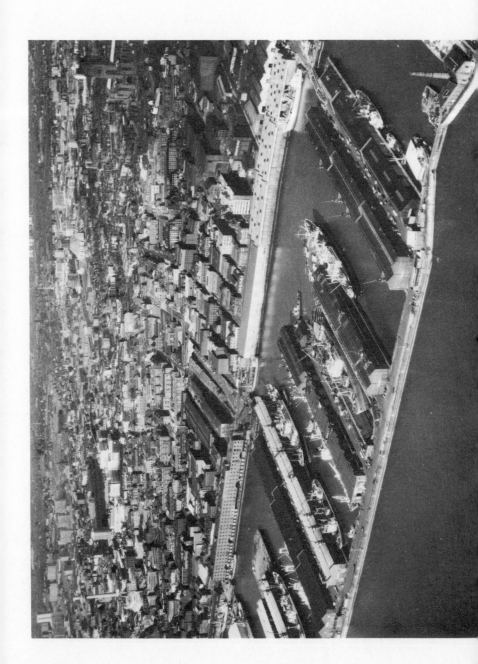

24

This is a port which has very strong connections with West Africa. It is in Britain.

1. How many ships are there in this small section of the docking area?

2. Are they all of the same type?

3. Identify one tug and one cargo vessel.

4. What is a tug used for?

5. Find a dry dock.

6. Find the entrance to these docks.

7. Why are people called 'pilots' necessary in a dock area?

8. Find out the meaning of the following terms: bonded warehouse and customs shed.

9. Bearing in mind the West African connections, what cargoes will be docked here?

10. Find two cathedrals. One is old, but the other has a very modern design.

11. There are new and old parts of this city visible in the picture. Find them and give reasons for your answer.

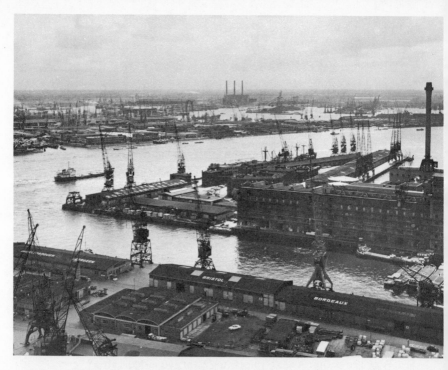

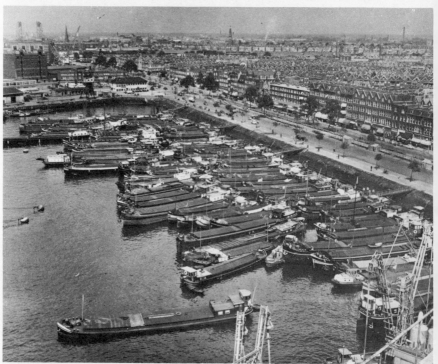

25

1. Why are the names Bordeaux, Bristol, etc. painted on the roofs?

2. What are the cranes for?

3. The barges at the right end of the nearest dock are self-propelled. What does this term self-propelled mean?

4. This picture shows only a small part of the world's largest port. It is in north-west Europe. Locate it on a map of the world.

5. In the middle distance are three large chimneys side by side. This is a power station. What power is produced here and how?

6. There are containers in this picture. What are they, and what is their purpose?

7. On the right of the foreground is a tall pillar. What is its purpose?

8. Describe briefly the physical landscape of the background.

BOTTOM

1. Name the type of vessel in the foreground.

2. Attempt to count how many there are.

3. In the harbour are two or three balls with ropes attached to them. What are they for?

4. At the top left of the picture is the beginning of a large docking area. What evidence supports this statement?

5. What evidence is there in the main street to support the statement that the weather is warm, or even hot?

6. The buildings behind the main street mark an old part of the town. Give reasons for this statement.

7. What is an entrepot?

8. Name several other entrepots apart from Rotterdam and Singapore.

9. Give reasons why industries grow on port sites.

10. Name four West African ports and three East African ports, and name some of the industries which have been established at these ports.

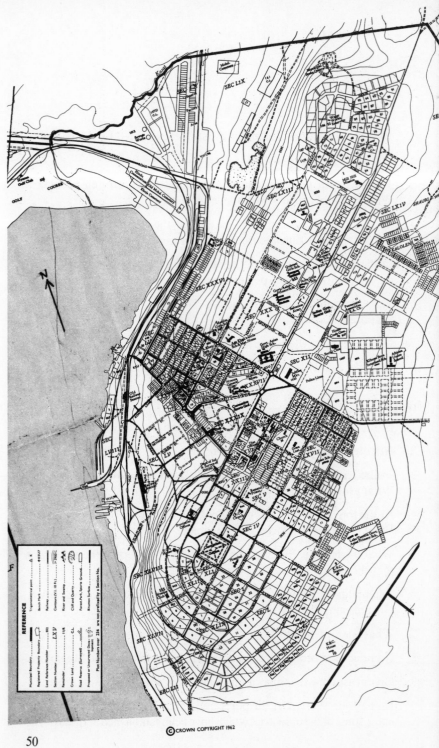

Introduction

The original scale of the map extract, was, 1:10,000, which means 1 inch on the map represents 277 yards approximately, as follows:

1 unit on the map represents 10,000 of the *same* units on the ground. Let the units be inches.

Therefore 1 inch equals 10,000 inches

$$\text{equals } \frac{10,000}{12} \text{ feet}$$

equals 833 feet

$$\text{equals } \frac{833}{3} \text{ yards} \qquad \text{equals 277 yards approximately.}$$

The aerial photograph is oblique, which means it was taken at an angle and therefore can have no regular scale:

Camera

Area photographed

The street pattern and coastline help to fix the photograph in relation to the map.

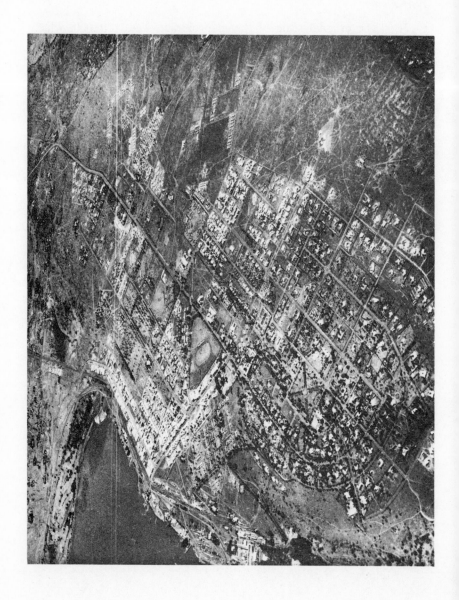

1. Identify the following features named on the map and shown on the photograph:

 Offensive Factory Area
 Golf Course
 Municipal Stone Quarry
 Mission Road
 Coronation Sports Ground
 (now renamed)
 Nyanza General Hospital
 Indian Gym Sports Ground

 Aga Khan's Girls' School
 and Maternity Home
 Muslim Girls' School
 Railway Stations, old and
 new
 Coronation Garden
 Kibuye Boys' Intermediate
 School.

2. From the photograph find the commercial and shopping areas in Kisumu. Now identify these on the map.

3. Where are the housing estates on the photograph (i.e. the residential areas), in relation to the rest of the town?

4. What evidence is there from both map and photograph that this is a well-planned town?

5. Enumerate the differences between a map and an aerial photograph regarding the information given to the viewer.

6. Suggest the main functions of Kisumu, quoting evidence from both map and photograph.

7. What type of natural vegetation exists outside the town?

8. The exact latitude and longitude of this town is as follows: Lat. 0 degrees, 3 minutes South; Long. 34 degrees, 47 minutes East. What is the name of the area of water?

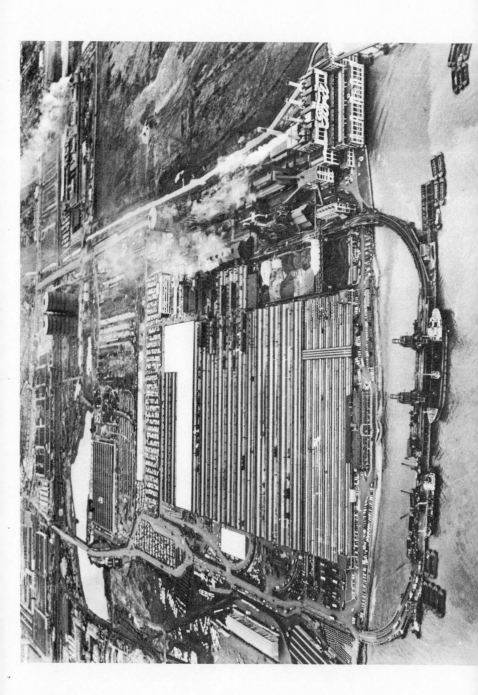

4. Economic

26

This factory is situated on the river Thames.

1. What article is produced here and by what company?

2. Draw a simple sketch of this factory to illustrate the following:
 (a) Small dock for incoming materials.
 (b) Storage area for these materials.
 (c) Part of the factory producing basic materials.
 (d) Rail link from (a) to (c).
 (e) Office block and headquarters of the factory.
 (f) The huge assembly factory.
 (g) Car-park for workers' cars.
 (h) L-shaped proposed extension to the assembly factory.

3. What raw materials will be needed?

4. In this connection the word assembly means 'putting together'—how many parts of the product made here can you name?

5. Are all these parts made at the one factory? Give reasons for your answer.

6. Offer probable reasons why this factory was sited here.

7. Many thousands of people work in this factory. Name some of the social situations which may arise concerning health, feeding, recreation and Trade Unions.

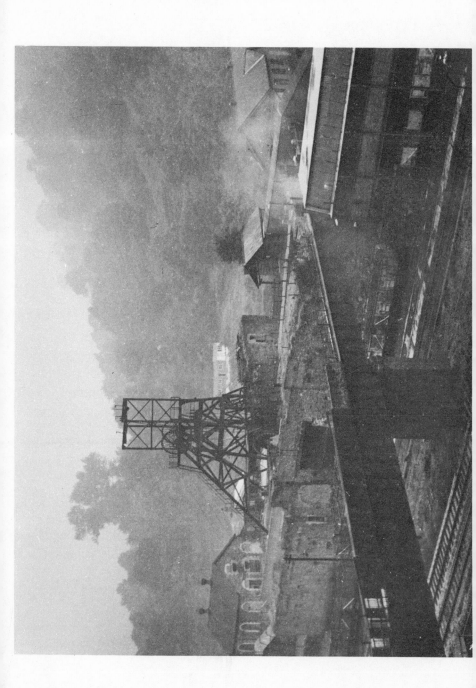

27

1. What fuel is being mined?

2. By what means is it reached?

3. Why is the atmosphere dirty?

4. Where is the fuel located?

5. What is the scaffolding with two wheels for?

6. By what means is the fuel taken away?

7. Why is that method used as opposed to any other?

8. Are there any dangers in working in this industry? If so, state some and why; it not, give reasons.

9. How did this fuel originate?

10. Name one well-known area in Europe and one in North America where this industry is carried on.

11. Name two areas in Africa where this industry is carried on.

12. Apart from the direct use of this fuel for power, by-products can be obtained from it—name four such by-products.

13. This type of fuel can be classified according to its heating capacity. State or find out the classification.

14. Name four other sources of power.

15. What are the main sources of power in your country and from where do they come?

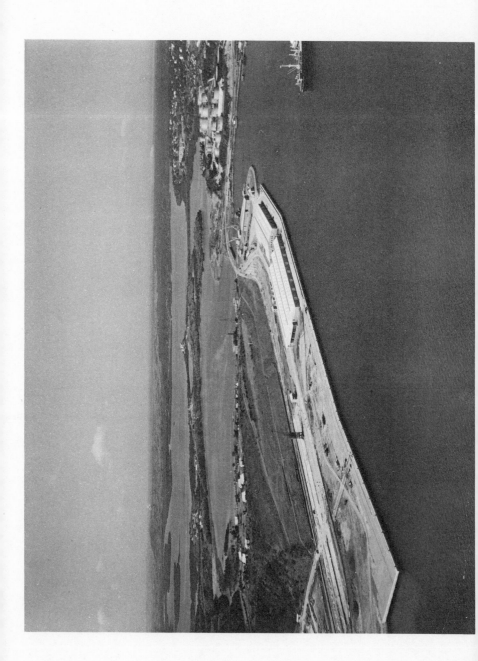

28

1. Name a likely coastal feature represented by this picture.

2. Give a general description of the land and water features.

3. The buildings in the foreground are under construction. For what will they be used? Give evidence.

4. In the right centre of the picture is a fuel terminal. Name the fuel.

5. From where does the fuel come and how is it put in the tanks?

6. Why are these containers or tanks kept apart from any other buildings?

7. The terminal is situated on an island which is linked to the mainland. There are two such links. What are they called?

8. Name two other methods of connecting an island to a mainland.

9. What evidence is there that the water areas in the middle distance are being reduced in size? What can be done to stop this happening?

10. How is the fuel transported from the large containers?

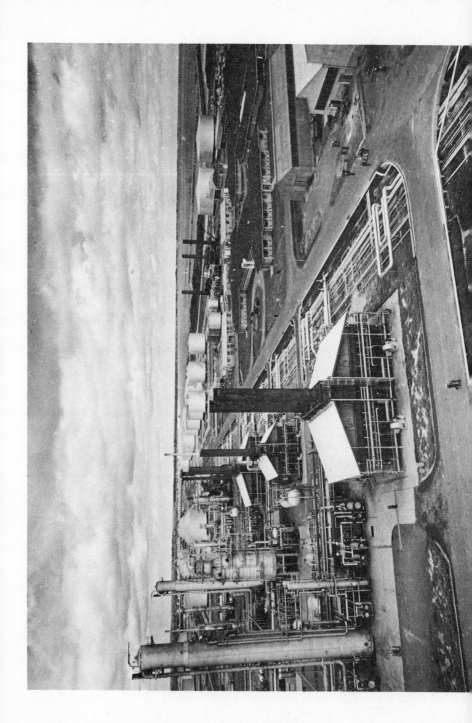

29

1. Do you think the two tall steel columns could be fractionating towers (see page vi)?

2. In the background there are huge cylindrical tanks. What are they for?

3. List five different kinds of petroleum products that may be stored on this site.

4. Is this refinery situated inland, or near the coast? Give clues to support your answer.

5. How many persons are shown in this picture? Who are they— workers or tourists?

6. Describe the physical features shown in this photograph.

7. Does the amount of mineral oil consumed by a country necessarily indicate the stage and extent of industrial development?

8. What are the alternatives to mineral oil as a source of power? (Hint: there are four main alternatives.)

9. How many oil refineries are there in your own country? Where are they?

10. Can the number of oil refineries in any country be taken as a rough indicator of industrial advancement? If so, give reasons. If not, state what other information is required.

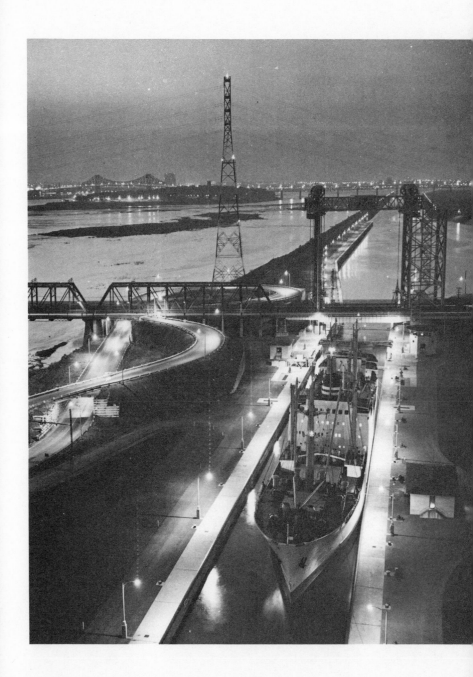

30

1. What aspect of communication does this photograph show?

2. Are lock gates, pumps and tugs usually essential for moving the ship along this type of water course? Name one other water course that does not require any of these.

3. Give two reasons why this man-made waterway is necessary.

4. What advantages does this aspect of communication offer?

5. Are construction costs prohibitive for similar projects of this type?

6. Name two other seaways, similar to this one, in different parts of the world.

7. What significance has the Central American route on the trade between Australasia and the new world with respect to (a) primary production (staple products), and (b) manufactures from the heavy industries?

8. From an atlas, find out (a) the actual distance, (b) the distance shortened by sailing through a canal, between the following pairs of places:

 (i) From San Francisco to New York.
 (ii) From New Zealand to England across the Pacific.
 (iii) From Australia to England across the Indian Ocean.

 Assume for this exercise that the Suez Canal is open.

9. Discuss the impact the St Lawrence Seaway has on trade in Canada and the U.S.A. on the one hand, and Western Europe on the other.

10. Name the builders of the Suez and Panama Canals.

31

1. Name this crop. How is it cultivated? How is it harvested?

2. What part of the crop is eaten?

3. Apart from food what is the other main use of this crop?

4. In what kind of environment is this crop grown?

5. Name firstly, the main areas of production in Africa, secondly the main areas of production in the rest of the world.

6. What must be done to this crop before it is exported?

7. This is done to reduce w----t, and v-----. Fill in the gaps.

8. The process is known as de--rt-c-t--n. Fill in the gaps.

9. Name four other crops which yield a vegetable oil.

10. In what parts of the world is there major production of these crops?

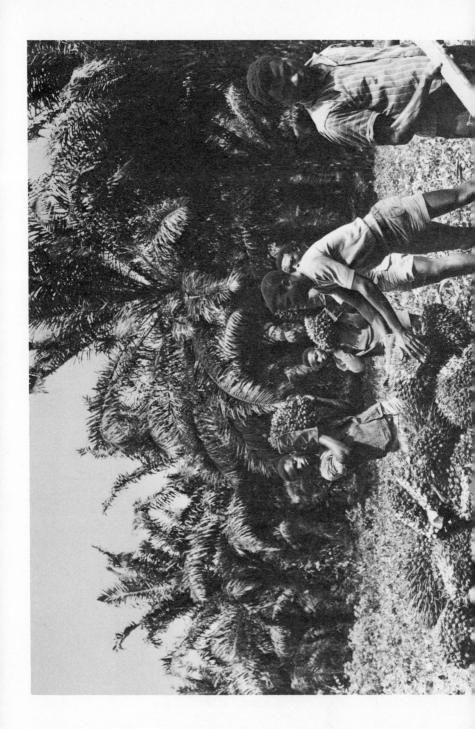

32

1. Name the crop.

2. What protection are the workers wearing?

3. Why is the protection necessary?

4. The crop, or fruit, is being put down at a collecting point. Where will it be then taken and for what reasons?

5. What are the other uses of this crop?

6. State fully the climatic requirements of this fruit.

7. Name the major areas in Africa where it is produced.

8. Name the major areas in the world other than Africa where this fruit is cultivated.

9. How can you tell this photograph was taken at the edge of a plantation?

10. Write a short essay on plantation agriculture using the following paragraph headings:
 (a) Definition and normal location.
 (b) How a plantation is created.
 (c) Two typical plantation crops and how they are cultivated.
 (d) Processing and marketing of these two crops.

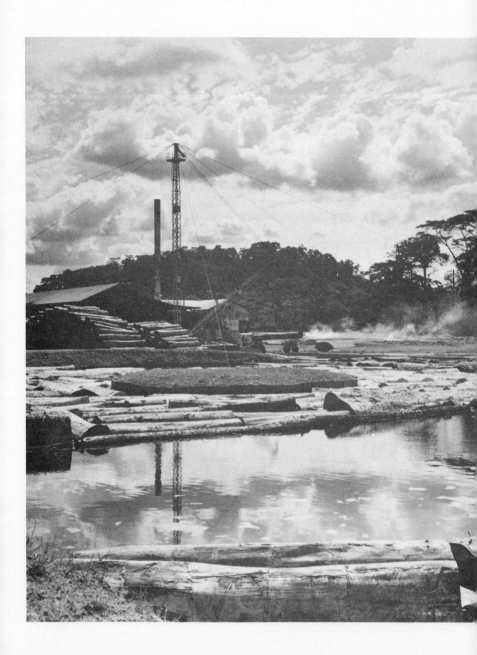

33

1. What is the main difference in texture between a hardwood and a softwood?

2. Locate the main areas in the world of both hardwoods and softwoods.

3. The foreground consists of a log-pond. What is a log-pond and what purpose does it have?

4. The original forest trees have been altered or partially treated so that they are now in the state you see, them, as logs in the pond. What has been done to the original trees?

5. Where was this done?

6. Why was it done there and not here at the mill?

7. What are the two main methods of transporting timber from the forests?

8. State some of the difficulties in extracting timber from tropical forest areas.

9. How can these difficulties be overcome?

10. Name four species of tropical hardwood.

11. What is the wood from the trees you have named in question 10 used for?

12. What do the terms plywood, veneer, sinker, and floater mean as applied to timber?

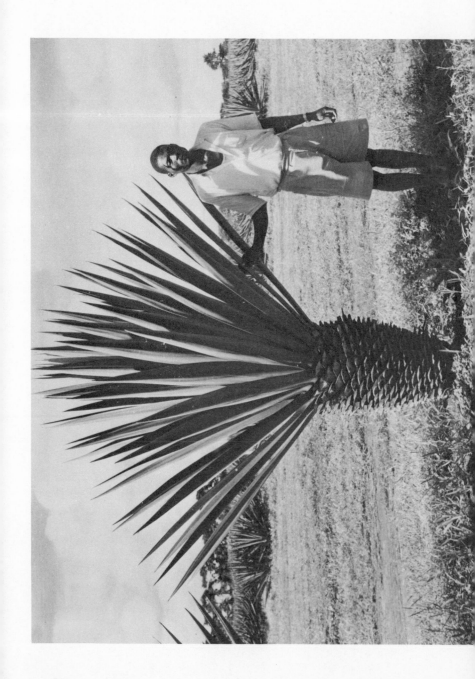

34

1. State the climatic requirements for this fibre.

2. Is sisal classified as a 'soft' or a 'hard' fibre? Why?

3. How long does the plant take to mature?

4. What is the average height of a mature sisal plant?

5. Was sisal indigenous to Africa, or was it introduced into Africa?

6. What is the average size of a mature sisal leaf fit for cutting?

7. Is the cutting of sisal leaves done seasonally?

8. What kind of knife is used for cutting the leaves—a sickle, a sword, or a long knife? How are the leaves conveyed to the factory?

9. At the factory, how is the fibre separated from the leaf pulp?

10. Find out what a decorticator is. Is it used in the sisal industry?

11. Are the fibres treated with chemicals for cleaning, or are they simply washed in clean, fresh water?

12. Name some of the countries which import sisal, and give a few domestic and industrial uses of it.

13. List six African countries where sisal is grown.

14. Is the sisal plant immune, or susceptible, to attacks by (a) insect pests and (b) fungi?

15. Do you consider the cultivation of sisal an example of (a) very easy cash cropping, (b) a difficult crop grown on a plantation basis, or (c) a hardy but most suitable crop for the African small-holders?

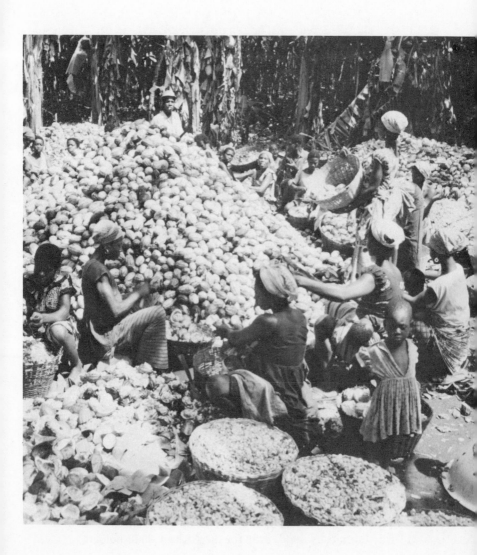

72

35

1. Name the crop.

2. What are the women doing to the crop?

3. After this process has been carried out what will be done to the contents of the baskets at the foot of the picture?

4. State the climatic requirements of this crop.

5. Name the major areas of production in Africa.

6. Name the major areas of production in the rest of the world.

7. Did this crop come from the plants seen at the top of the picture?

8. What are these plants?

9. What is a Marketing Board?

10. What are the main purposes of a Marketing Board?

11. Name the uses of this crop.

12. Differentiate between a luxury crop and a staple crop.

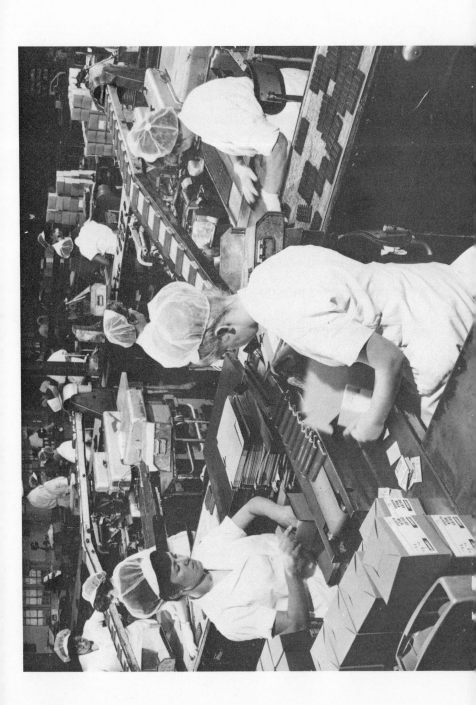

36

1. What item is being made at this factory?

2. Apart from cocoa what are the necessary ingredients of this item?

3. Why are all the women wearing some sort of headgear?

4. What are the workers at the front of the photograph doing?

5. What is 'automation' in a factory?

6. Is there any evidence of automation here—if so, what is happening?

7. One worker is wearing gloves—why?

8. Apart from the product in the picture what other items are made from cocoa?

9. In any factory some jobs are suitable for women, and some only for men. Make two lists of these jobs, one for men, one for women.

10. Why is this product not normally made in tropical countries?

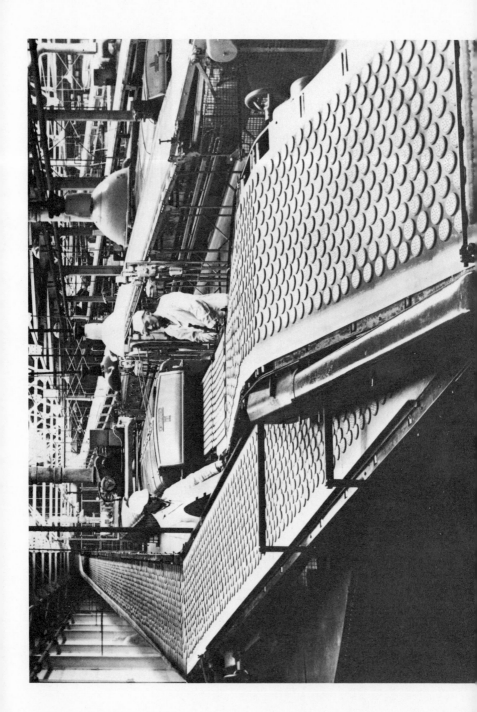

37

1. What does this factory produce?

2. The two men are standing on either side of a machine numbered 3809. What is this machine?

3. What power operates this machine?

4. Explain why there are very few workers in this part of the factory.

5. What are the main ingredients for the product in this picture?

6. What evidence is there that this factory operates 24 hours a day?

7. What is the meaning of the term 'shift system' as applied to factory workers?

8. Under what circumstances is a shift system necessary?

9. Explain the terms overtime, redundant, apprentice, skilled worker, and pensioned off in relation to factory workers.

10. Safety precautions are necessary in *any* factory. List the dangers of jobs in the following places:
 (a) sawmill
 (b) blast furnace
 (c) chemical factory
 (d) factory making television sets.

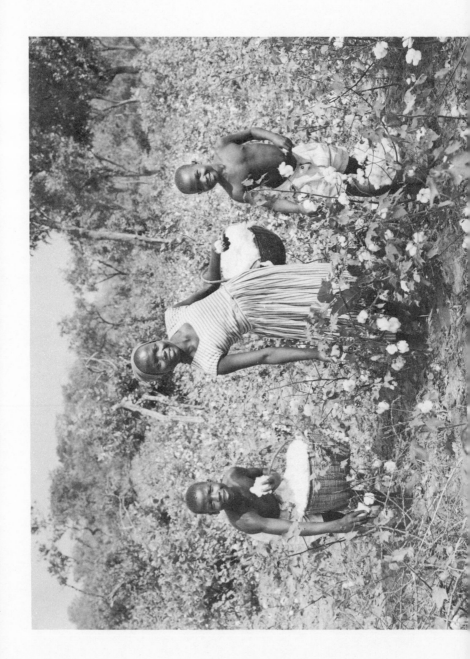

38

1. Name the crop.

2. What is the connection between the flower, the boll, and the lint of this crop?

3. State the climatic requirements of this crop.

4. Name the major producing areas in Africa.

5. Name the major producing areas in the rest of the world.

6. The harvested crop contains seeds. What can they be used for?

7. How, and in what place, are the seeds extracted?

8. What is a fibre?

9. Name two other natural fibres apart from this one.

10. What is a man-made or artificial fibre?

11. Name two artificial fibres.

12. What raw materials provide sources for man-made fibres?

13. This picture was taken in East Africa. Name a likely location.

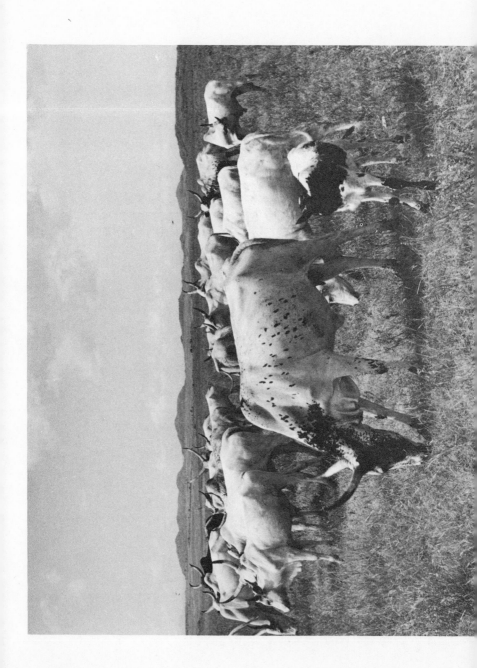

39

1. Describe the physical landscape.

2. Give a reasoned account of the natural vegetation.

3. What kind of animals are in the picture?

4. What does the word 'domesticated' mean as applied to animals?

5. What likely pests and diseases may affect these animals?

6. Make a complete list of the uses this animal has, once it has been slaughtered.

7. This picture was taken in Nigeria—name a likely location and give full reasons.

8. What is a 'nomadic herdsman', and how does he make his living?

9. In what kind of environment are nomadic herdsmen found?

10. Define the terms ranching, pastureland, and pedigree stock.

40

1. Maize is growing in the foreground. The crop in the middle distance is rice. What evidence is there that it is irrigated rice?

2. There are several methods of irrigation. Draw diagrams to illustrate shaduff, perennial irrigation, sprinklers.

3. What total annual rainfall is required below which irrigation is necessary?

4. Why must distribution of rainfall be considered as well?

5. What is a paddy?

6. What difference is there between upland and lowland rice?

7. Where are the main rice-producing areas in the world?

8. What are the main features about annual rainfall in these areas?

9. Find out the difference between polished and unpolished rice.

10. What evidence is there to suppose that this farm does not belong to a small 'peasant' farmer, but to a larger organization?

11. This farm is part of a 'land settlement scheme'. What does this term mean?

12. Approximately what area do the rice-fields cover?

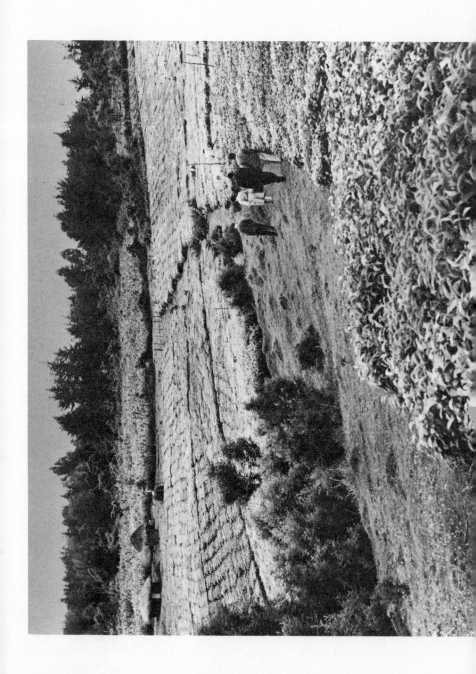

41

1. Name the crop growing in the foreground and middle distance.

2. All the bushes are of a similar height. Roughly how high are they?

3. Why are they kept cut to this height?

4. The ground on which the bushes are growing is not flat. Is this deliberate and if so, why?

5. There are coniferous trees in the background which indicate possible low temperatures. Is frost a danger to this crop?

6. What is frost?

7. Which countries are the main producers of this crop?

8. How is the crop harvested?

9. This picture was taken in East Africa. Name a likely location.

10. Where are the major world markets for this crop?

11. Is irrigation needed here?

12. Write a short account of what happens to the crop from the time it is harvested until it is consumed.

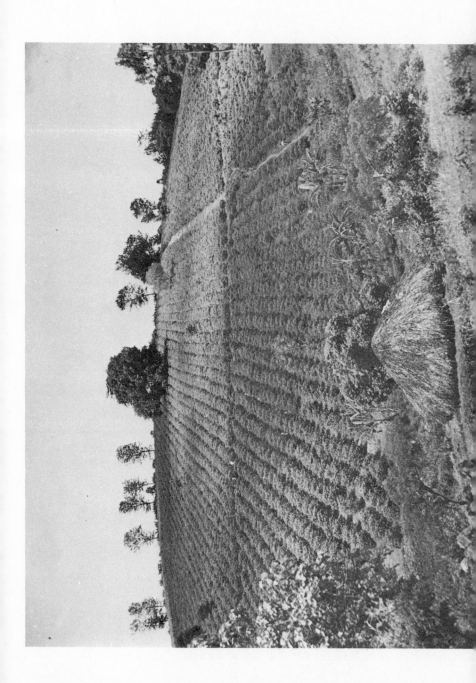

42

1. This crop provides one of the most popular beverages in the world. What is it?

2. State the climatic requirements of this crop.

3. Brazil is the world's largest producer—what other countries produce the crop?

4. Why are the plants evenly spaced?

5. Why have odd trees been left to grow in this plantation?

6. What processes must the fruit go through before it can be used as a beverage?

7. This drink is sold in powder or 'instant' form, ground, as an essence, and in its original form. Identify these forms from the point of view of the consumer.

8. What does 'instant' mean in this case?

9. Why is plenty of labour needed on such a plantation?

10. This picture was taken in Kenya. Name a likely location, or area.

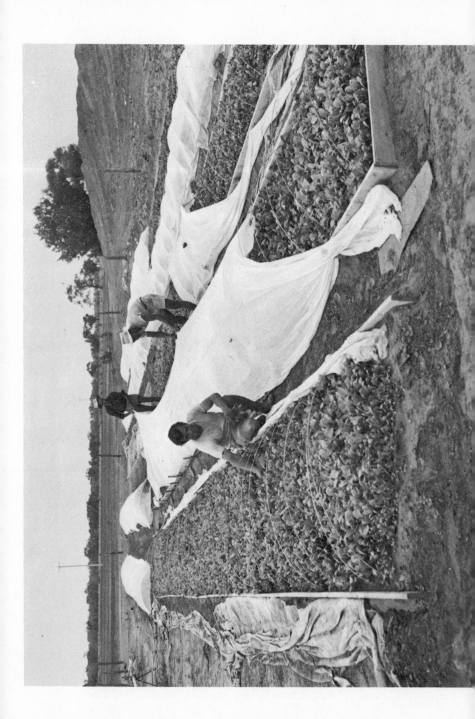

43

The photograph shows the cultivation of tobacco.

1. State the climatic requirements of this crop.

2. What type of soil is best suited to this crop?

3. In this photograph is the crop young or mature? Give reasons for your answer.

4. Why is a cover put over the plants?

5. Name four large tobacco-growing countries, and give the particular districts where tobacco is grown in each country.

6. Do all the four countries you have named in question 5 also export cigarettes?

7. How is raw tobacco prepared for export? Describe the stages in preparing the tobacco leaves for shipment overseas to the cigarette manufacturers.

8. In which country do you think this picture could have been taken?

9. Import duties are generally imposed on tobacco leaves, cigars and cigarettes, because (a) these are luxury items, (b) they are good sources of revenue, and (c) this raises their price and so discourages more people from smoking. From the viewpoint of the Economic Geographer, which of the above is an acceptable answer? (If you are offering economics at 'O' Level you may possibly advance economic arguments for such general questions with an economic bias.)

10. State whether tobacco is grown from the fruit or from the seed.

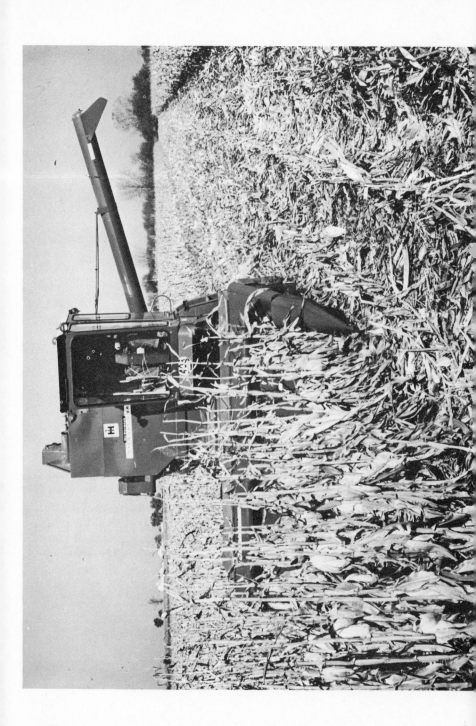

44

1. What is being harvested here?

2. What is the cereal known as (a) in the U.S.A., (b) in Britain, (c) in Eastern Transvaal, S. Africa, and (d) to botanists?

3. Name seven states in the U.S.A. where this cereal is extensively cultivated.

4. Name two or three regions in Europe where this cereal forms an important food for the poorer sections of the population.

5. State the climatic conditions and soil type best suited to the cultivation of this crop.

6. Is this crop grown in the Mediterranean regions?

7. As a rule, is this crop commonly harvested by mechanical harvesters?

8. This grain is used as a food by three very different species: (a) homo sapiens, (b) animals, and (c) birds. Give a specific example of each.

9. This cereal can be exported in three ways, or forms. What are they?

10. Name a region where this photograph could probably have been taken.

11. After harvesting this crop, how can a farmer make profitable use of the leaves and stalks?

12. Why is this machine called a combine-harvester? What cereals are harvested by combine-harvesters? List as many as you can.

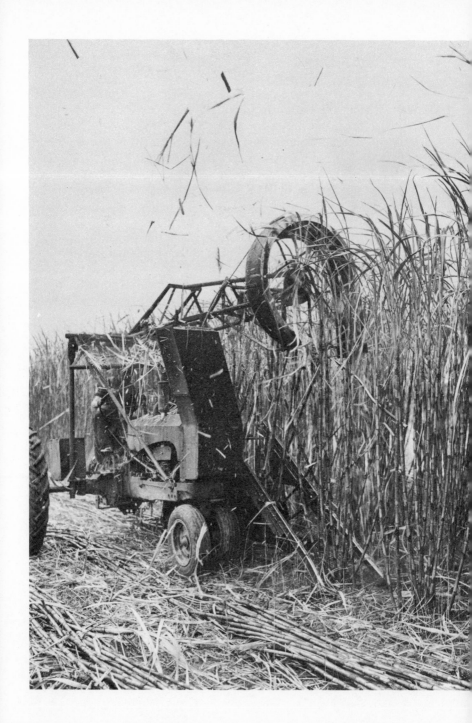

45

1. What does this photograph show?

2. Name the mechanical harvesting device used.

3. Is mechanical harvesting generally used for this crop?

4. Is burning away the leaves the usual method of harvesting?

5. What disadvantageous effect does burning have on the stems of the plant?

6. Why must the leaves be burnt, if burning is detrimental to the yield?

7. State the optimum climate and soil type most suitable to the growth of this crop.

8. Is manuring an optional or an essential requirement for this plantation crop?

9. Describe the stages whereby this crop is turned into a food commodity.

10. Name the countries which are the main exporters of this food commodity.

11. What nutritive elements does this product take from the soil?

12. Name a likely country where this picture could have been taken.

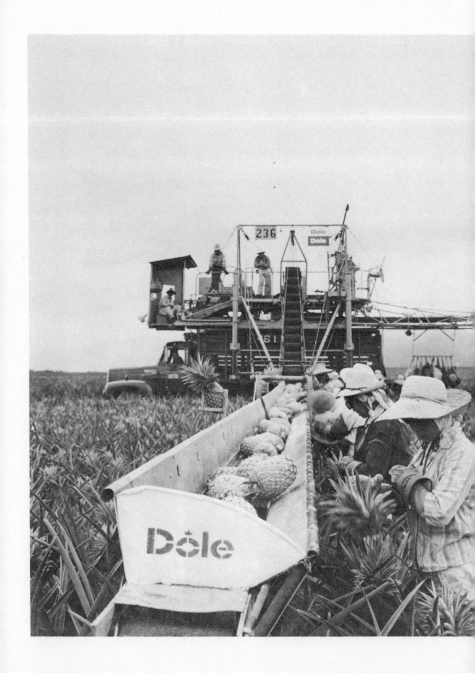

46

This photograph shows a tropical fruit planation.

1. How is the fruit first planted?

2. Is shading for the young plants necessary in the early growing stages? Why?

3. State the climatic conditions which favour the cultivation of this fruit.

4. How long will it take for (a) the first crop and (b) successive crops of this fruit to mature?

5. How is the fruit harvested?

6. Why must the workers (a) wear gloves, and (b) cut off the crown from each fruit?

7. Is the fruit usually exported (a) raw or (b) in tins? Why?

8. Name two conditions which favour the export of this fruit in tins.

9. Name two other ways of using this fruit as a food rather than as a dessert.

10. Name four countries which export this fruit.

11. Do you think the long trench could be a conveyor belt? Why?

12. Are the workers putting the fruit into the conveyor-like trench, or are they simply removing the crowns?

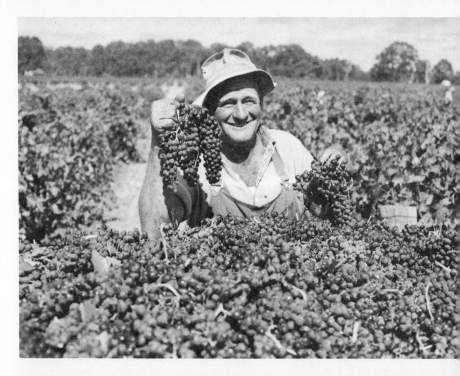

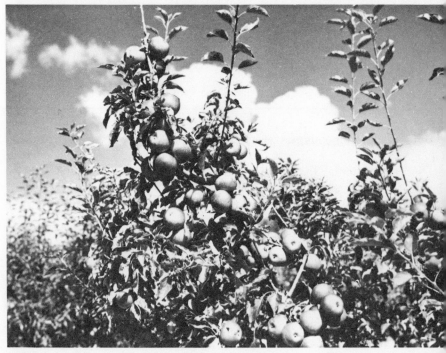

47

The photographs show two different kinds of fruits. For each of them:
- (a) name the fruits;
- (b) state whether the fruit trees are evergreen or deciduous plants;
- (c) describe the geographical conditions that favour large-scale cultivation;
- (d) name three countries where the fruits are grown on a commercial basis for export;
- (e) name five countries which are importers of the fruits;
- (f) describe how the fruit is packed for export.

TOP
1. State whether a beverage can be made from the fruit.

In numbers 2 to 5, fill in the blanks:
2. When dried, this fruit is known collectively as (i) or (ii) or (iii)
3. The cultivation of this fruit is known as, but any piece of land on which it is grown is called a
4. The countries where this fruit is successfully cultivated have a climate known as '..................' which is characterized by,, winters and,, summers.
5. The fruit can therefore be grown in both the Northern and Southern

BOTTOM
6. Does the fruit grow on shrubs or on trees?
7. Is the fruit tree susceptible to frost?
8. Name two best known regions (in America) for the cultivation of this fruit.
9. Apart from being a dessert, name one other use of this fruit.
10. Which type of fruit, in the two photographs, can withstand a wider range of temperature for its growth? Cite regional examples to support your answer.
11. Which kind of fruit, in the two pictures, is more important as an item of international trade? (Hint: List the number of importing and exporting countries for each kind of fruit, as well as the quantity involved.)

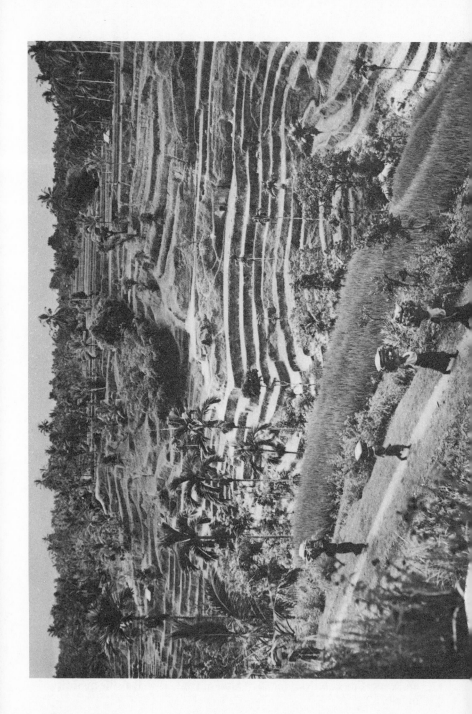

48

1. Name this type of cultivation and at least four countries practising it.

2. State, with reasons, the chief crop that is grown here.

3. In what climatic regions is this form of cultivation practised?

4. Near the foreground there are three palms of almost the same height. What palms are they?

5. Under what ethnic group would you place the people of this region?

6. Are there any houses in this picture? If so, how many?

7. In what ways do you think the land, in this picture, is being usefully utilized?

8. Sum up the main features in this photograph.

9. Slopes may be terraced for various reasons, e.g.:
 (a) they contain very fertile soil,
 (b) the region is hilly and there is an acute shortage of farming land,
 (c) the higher altitudes enable certain temperate crops to be grown in tropical regions.
 Name a region where cultivation is practised for each of the above reasons.

10. Explain why this type of cultivation is not practised in Switzerland or Austria.

11. Name (a) the crops grown and (b) the localities in the Mediterranean lands where terraced cultivation is adopted.

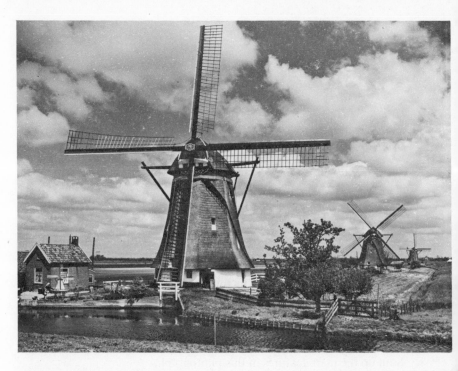

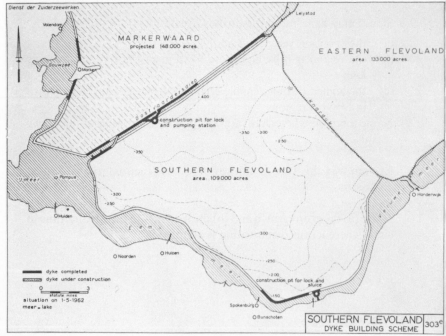

49

The windmills, together with the map, are self-explanatory.

1. What do the portions of the map in different shadings stand for?

2. This map shows a portion of a certain country. Name that country.

3. What are the functions of the locks and sluices as shown on the map?

4. From the map, what can you say of the surface of Southern Flevoland?

5. What was Southern Flevoland once a part of? Give reasons to back up your answer.

6. What economic activities, if any, do you think the people of Southern Flevoland are engaged in?

7. Why are there so many windmills within such a short distance of one another?

8. What are the windmills for, and why must they be working continuously?

9. Other than the wind, what other sources of power can do the work of the windmills?

10. State two possible uses to which the land behind the three windmills, can be profitably put (other than for building houses).

11. 'Drainage and irrigation appear to perform functions that are apparently opposite.' Do you agree? Define drainage and irrigation and show how they can sometimes be complementary.

12. Name (a) one country where drainage is extremely important, and (b) one country where irrigation is extensively practised. List the crops grown in countries (a) and (b).

13. Name two countries where wind pumps are important, and give reasons why they are used instead of windmills.

14. Name a country and give an example where each of these (i.e. a windmill and a wind pump) is put to some practical and profitable use.

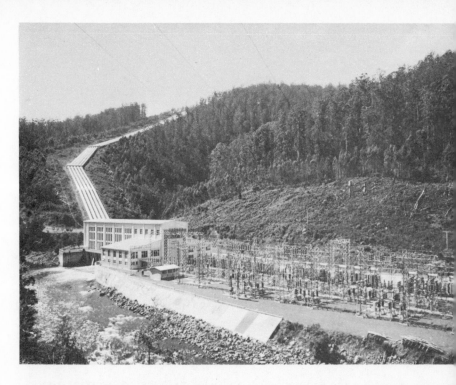

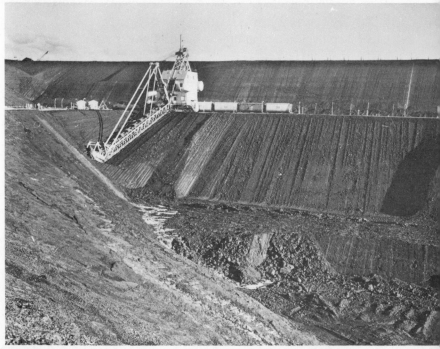

50

For each picture (which shows a valuable source of power):
 (i) Name the kind of power produced, and give reasons.
 (ii) Explain how the source of power is obtained.
(iii) Name a location where the photograph might have been taken.

TOP
1. State one economic prerequisite and three physical conditions that are necessary for the successful production of this type of power.
2. 'Power obtained by this method may not be necessarily cheap. It is indeed surprising that it is ever cheap.' Under what conditions then, do you think it can be cheap?
3. Contrary to popular belief, a great height for the water to fall through is not absolutely necessary. A good example is the St Lawrence Seaway. Name an equally good example in the U.S.S.R. similar to that of the St Lawrence Seaway.
4. Complete the following with reasons: 'Most of the water power in Africa and South America remains unused because of a lack of (i) and (ii)'

BOTTOM
5. Name the mineral that is being scooped up.
6. What is that huge machine called?
7. Are the rail wagons used for transporting the mineral away? Why?
8. What is this type of mining known as?
9. Describe another method of mining this kind of mineral.
10. 'Mineral' is a general term meaning 'a substance obtained by mining'. Give geographical sense to the term 'mineral', by suggesting a more appropriate definition. What is meant by 'potential mineral resources'?
11. Under which of the following category would the second photograph come?: (i) metallic mineral, (ii) non-metallic mineral, (iii) liquid fuel mineral and (iv) solid fuel mineral?
12. Generally speaking, countries in the Southern Hemisphere (S. America, Africa, Australia, New Zealand) are considered as being deficient in the mineral shown in the second photograph. Is this correct?
13. Write down the name of one city in Africa, one in the U.S.A., and one in Europe where the above mineral is mined.

Figure 1

Illustrate the following figures for temperature in the form of a graph. (ALEXANDRIA)

A suitable Vertical Scale would be 1 inch = 10°Fahrenheit.

NOTE: When illustrating only *one* set of figures the choice of vertical scale does not matter very much. But when several are to be shown, for comparison purposes, the same scale must be chosen throughout. Before selecting it attention must be paid to the extremes of temperature, i.e. the highest and lowest to be shown.

Jan	Feb	Mar	Apl	May	Jun	Jul	Aug	Sep	Oct	Nov	Dec
54	57	63	70	77	82	84	83	78	75	66	59 deg.

Fahrenheit

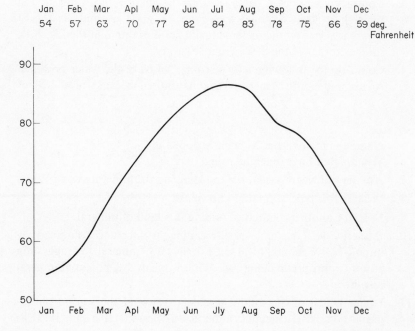

Part Two

Introduction to the Interpretation of Statistics

This section deals with the most common types of exercises involving statistics. Methods are examined and explained; and this is followed by a few suggested exercises for the student.

PRESENTING AND INTERPRETING STATISTICS

The presentation of statistics in the form of graphs or diagram of various types is a relatively new branch of geography. It is attractive because it avoids lists of tedious figures and long written discussions; instead a visual interpretation is provided. The main guiding principle is *simplicity* plus *clarity*.

Graphs

The graphing of statistics is very useful when dealing with a large number or range of figures, because any scale can be selected which suits the figures. Secondly, two items can be shown as there are two axes, a horizontal and a vertical; the horizontal axis is often used to show time (in years or months). If the variation is continuous, as in the case of temperature figures (Figure 1), a smooth curve should be drawn; if the variation is discontinuous—namely, there is no connection between one time period and another—distinct straight lines should be used (Figure 2).

Bar Graphs

(a) *Separate.* Most students will be familiar with the presentation of a bar graph to illustrate rainfall statistics (Figure 3). They can, however, also be used to show, for instance, production figures. Again, the scale, whether it is vertical or horizontal, is governed by the maximum and minimum (Figure 4).

(b) *Combined.* One bar graph can be used to show a set of statistics— provided clarity is preserved. The length of the bar represents the total, and it is subdivided in proportion (Figure 5).

Figure 2

COCOA PRODUCTION IN GHANA IN SELECTED YEARS

(Figures are in thousand tons)

1938	263		1949	264
1939	281		1950	267
1940	224		1961	405
1945	232		1962	421
1948	214		1963	405

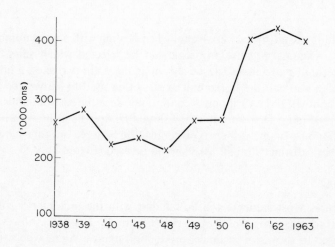

Figure 3
Illustrate the following rainfall statistics (Lagos).

A suitable Vertical Scale would be 1 inch=5 inches of rain (or 1 centimetre=$\frac{1}{2}$ inch of rain).
(The bars may be shaded or coloured if desired.)

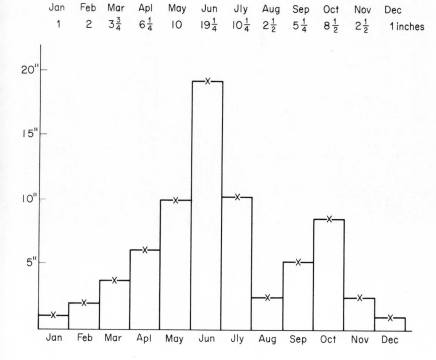

107

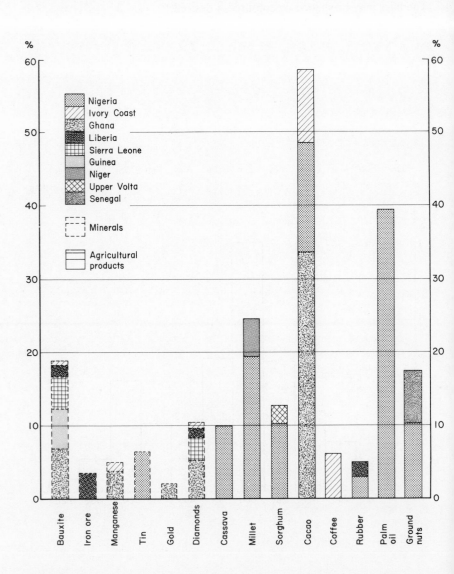

Figure 4

WEST AFRICAN PRODUCTION OF CERTAIN COMMODITIES EXPRESSED AS A
PERCENTAGE OF TOTAL WORLD PRODUCTION

Figure 5

BAR GRAPH TO ILLUSTRATE CHANGE IN FUEL USED IN BRITAIN

(Production of electricity by nuclear and hydro means)

Draw up a table to show percentages. Remember that the sections of the line showing total fuel consumption add up together to 100%.

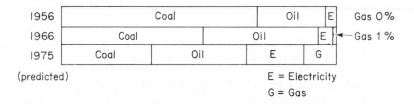

(predicted) E = Electricity
 G = Gas

Pie Graphs

In this case a circle is divided into segments—each segment being drawn in its correct proportion (Figure 6). It is thus easy to compare the sizes of the various segments within one circle (Figure 7). But it can be difficult to compare the sizes of segments in different circles.

Population Structure Graphs

A type of bar graph coming into increasing use is the 'Structure of Population' graph. With the rapid advance in the study of human and economic geography has come the realization that in any area (village, town, or nation) the numbers of people in each age group is very significant (Figure 8). While generalizations can be dangerously misleading, it can be said that in any population group there are three categories: the old, the young and the middle-aged group. The old and the young do not normally contribute to the economy of the group—the old have finished working, the young have not yet started. Thus the middle-aged group must support the other two groups. More detailed information can be derived from a population structure graph, but only in individual cases, not in the general sense.

WHOLE MILK CONSUMPTION IN AUSTRALIA
1960

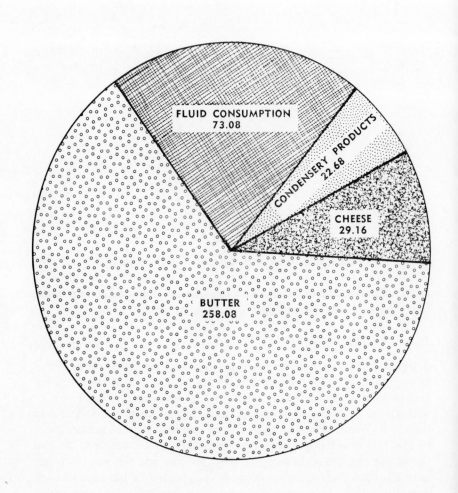

FLUID CONSUMPTION
73.08

CONDENSERY PRODUCTS
22.68

CHEESE
29.16

BUTTER
258.08

Figure 6

(Figures in thousand gallons)

(a)	Butter	508,814
(b)	Cheese	63,469
(c)	Condensery Products	48,834
(d)	Fluid Consumption	157,923

Express these figures as a Pie Graph.

1st Stage: Find Total: 779,040.

2nd Stage: Express each product as a fraction of the total and multiply by 360.

(a)	comes to	235·12°	=	235	
(b)	comes to	28·88°	=	29	
(c)	comes to	22·56°	=	23	
(d)	comes to	72·97°	=	73	Total 360°

Total = 359·53° which is not a complete circle of 360°. The reason is complete division seldom comes to 360° exactly unless several decimal places are determined. However, approximation is quite acceptable, this giving the second column. Also, it is very doubtful if the human eye can detect differences of 1 or even 2 degrees in the 360 of a circle.

3rd Stage: Draw a circle and these angles to show the various segments.

Figure 7

It is quite useful to use circles of varying size, so that the area of each is proportional to the total quantity and various subdivisions can be shown at the same time. To draw a set of circles whose areas are proportional to set quantities find the square root of each quantity and use it as the radius of the circle calling the square root any convenient unit, e.g. 1/16th of an inch or 1 millimetre.

Example Values in Tons

A = 1,250
B = 2,019
C = 2,575
D = 3,776

Therefore Radii = A 12·50
 B 20·19
 C 25·75
 D 37·76

Scale—Let 1 mm represent 100 tons.

Figure 8

POPULATION STRUCTURE GRAPHS FOR BRAZIL, JAPAN AND U.K.

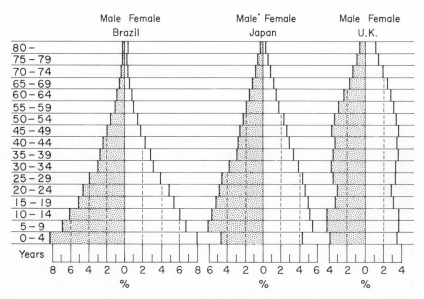

The horizontal axis can show EITHER:
 (a) Percentage (as in this case) OR:
 (b) Total population – usually expressed in thousands.

Colour

Most students will be familiar with the use of colour as it is often seen in atlas maps. It can be used in two main ways:

1. Graded from light to dark as follows:

 Yellow orange brown green blue red black

 Light -------- getting darker --------- darkest.

The most common use of this sytem is in showing altitude (Figure 9).

2. Ungraded. In this case (as with certain types of shading, see later) colour is used to show a list of unconnected facts; therefore no grading or order of colour is necessary (in figure 10 shading has been used instead of colour for the sake of economy).

113

Figure 9

GRADING OF COLOURS

Altitude

(=yellow) – 600 ft

(=orange) 600–1,200 ft

(=brown) 1,200–1,800 ft

(=green) 1,800–2,400 ft

(=blue) 2,400–3,000 ft

(=red) 3,000–6,000 ft

(=black) over 6,000 ft

NOTE: There is no need to use the colours in strict rotation. If only four or five divisions are needed, any four or five colours may be taken, so long as they appear in the correct order. For example:

(=yellow) 0–1,000 ft

(=green) 1,000–3,000 ft

(=red) 3,000–6,000 ft

(=black) over 6,000 ft

114

Figure 10

(Taken from *Philips' School Atlas for E. Africa*, 1964)

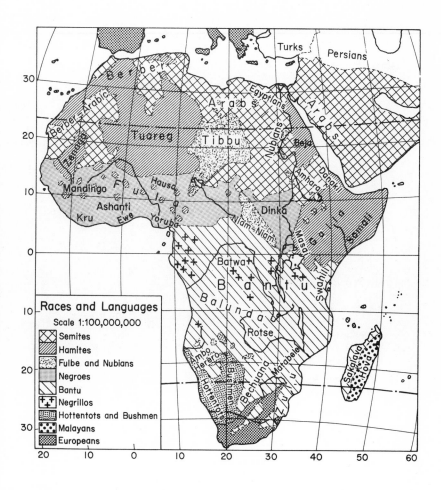

Figure 11
AFRICA—MEAN ANNUAL RAINFALL.

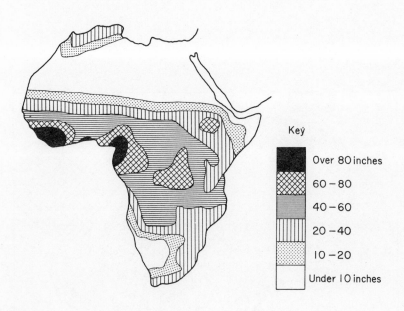

Key

Over 80 inches

60 – 80

40 – 60

20 – 40

10 – 20

Under 10 inches

Shinto and Buddhism

Buddhism

Protestant

Roman Catholic

Chinese religions
and Communism

East Orthodox

Tribal religions

Hindu

Islam

Judaism

Figure 12
KEY FOR WORLD RELIGIONS

Shading

If this method is to be progressive, as shown in Figure 11, there is one big disadvantage: the scope or range is limited to about five or six divisions. It becomes increasingly difficult to distinguish between the signs if more divisions are used. Therefore it is perhaps better to make the two extremes final, namely *blank* and *solid*.

The second type of shading, if it can be called shading, is merely a collection of different signs or types of shading with no connection at all. (Figure 12). Thus there is no limit to the range or scope.

Dots

This method can be used in a similar fashion to graded shading as in Figure 13.

Equal Size. It is also frequently used to show density of figures over an area (it may also be used to show distribution but this aspect is very difficult and entails the use of several reference maps). One dot represents a pre-selected number. Difficulties arise in the choice of the size of the dot. They may be too big, or they may be too small. The student should consider two factors: (a) how much space is available for the dots on the map? (b) the maximum and minimum number of dots which will be used. If necessary, alter the scale; for instance, if '1 dot represents 50 people' is going to lead to one area being a solid mass of dots then the dots must be small; the scale could be halved so that 1 dot represents 100 people.

Varying Sizes of Dots. This method is used to depict quantity (Figure 14). The maximum limit will be set by the space available on the map or diagram.

Flow-Line Maps

'Movement' may be represented by various forms of dynamic map (Figure 15). The term flow-line is used to describe a movement map which shows the direction or route followed by means of a line representing the route concerned. The quantitative (amount) impression is conveyed by the width of the lines. Very detailed information must be available for the construction of such a map; and curves are very difficult to draw.

118

Figure 14
ELECTRICITY PRODUCTION
(Figures in Kilowatt–Hours)

0 – 500
500 – 1,000
1,000 – 5,000
5,000 – 10,000
Over 10,000

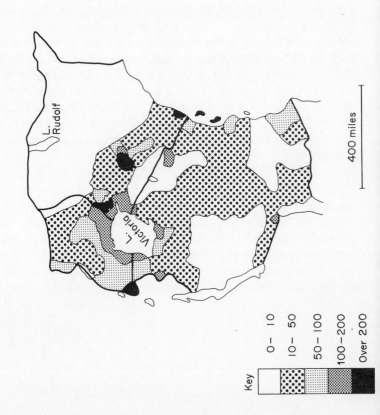

Figure 13
EAST AFRICA: POPULATION DENSITY

Key

0– 10
10– 50
50–100
100–200
Over 200

L. Rudolf

L. Victoria

400 miles

Figure 15

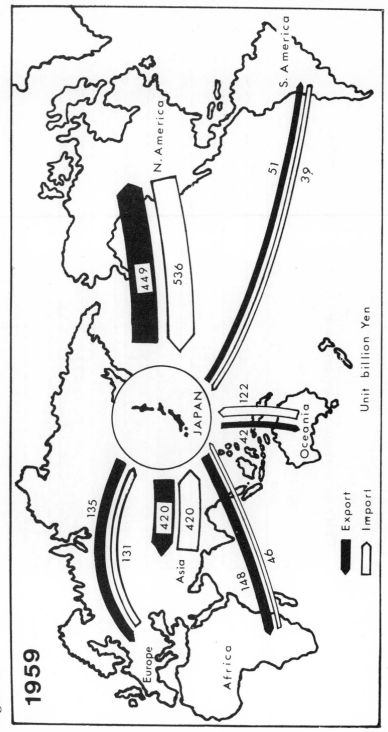

1959

N.America

S. America

449 536

51

39

Unit billion Yen

JAPAN

122

42

Oceania

135

131

420 420

Asia

46

148

Europe

Africa

Export
Import

119

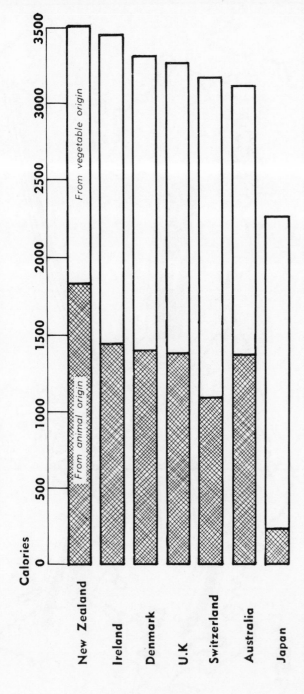

Daily nourishment per capita by Country (1962 – 1963)

Calories

From animal origin

From vegetable origin

New Zealand
Ireland
Denmark
U.K
Switzerland
Australia
Japan

0 500 1000 1500 2000 2500 3000 3500

Suggested Exercises for Students

QUESTION 1.

(a) What do the data tell of the daily nourishment of food from animal origin in the seven countries named?

(b) Why do New Zealanders have the highest daily calorific consumption from animal origin? Do geographical factors have anything to do with the New Zealanders consuming more meat daily?

(c) Why has Japan the lowest calorific value, from animal origin, per capita in view of the abundant catches of fish by Japanese fishermen? Does this suggest that the Japanese dislike food from animal origin?

(d) Could the data in the above diagram be more effectively represented on any other kind of diagram? If so, draw your diagram. If not, explain your reasons.

(e) The Japanese people consume more food from vegetable origin than any of the six other countries. Explain why this is so.

(f) What are the countries whose daily calorific values from food of (a) animal origin are nearly the same, (b) vegetable origin are nearly the same?

(g) There are no large areas for cattle and sheep in the U.K. How, and from where, does the U.K. get the meat for its people?

(h) GENERAL: Compile a list of foodstuff derived from vegetable origin.

(i) Name the countries, in the diagram, which are also exporters of foodstuffs of animal origin. What geographical factors have enabled them to engage in this particular food trade?

(j) From the diagram, name the countries which are the probable importers of meat and meat products. Explain why they must import these animal products.

WORLD CEMENT PRODUCTION, 1960

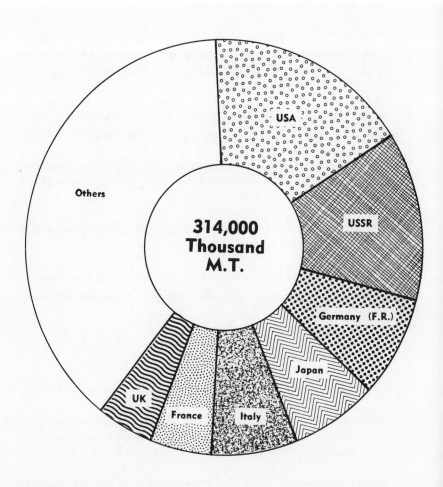

QUESTION 2.

The diagram shows the major cement-producing countries and their respective outputs in 1960.

(a) Which of the countries are outstanding in the production of cement? Account for their predominance in cement production.

(b) Give an explanation why some countries produce only small quantities of cement. Are such countries included in this diagram?

(c) List the main raw ingredients used in the manufacture of cement.

(d) GENERAL: Which of the following countries are most likely to use larger quantities of cement?—

 (i) a large, advanced and highly industrialized country,

 (ii) a densely populated, small developing country with good financial resources,

 (iii) a large, under-developed country, with rich forest resources scattered over vast areas; its population is small, and financially it is poor.

(e) What are 'prestige' projects? Give some examples, and suggest geographical and economic reasons whether such projects are essential or undesirable (for a large section of the populace). Is the building of a large modern hospital a 'prestige' project?

(f) GENERAL: If a poor country gets a loan from the World Bank to enable it to build huge dams to harness its potential water power resources, do you consider this construction a 'prestige' project? Give reasons to support your answer.

(g) Draw a columnar graph to represent the thousands of metric tons of cement produced throughout the world in 1960. (Hint: your diagram should have eight columns.)

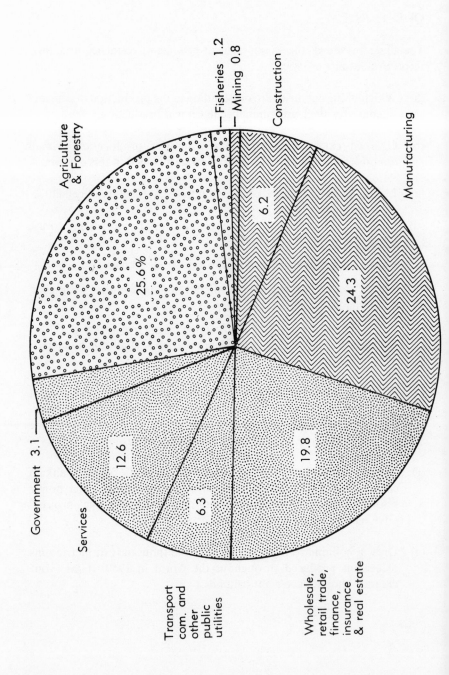

QUESTION 3.

The diagram shows persons employed by industry in Japan, totalling 47 million in 1964.

With reference to the diagram:

(i) What was the percentage of unemployed persons?

(ii) Of the 47 million employed, state the number of persons engaged in:

(a) Agriculture and Forestry

(b) Manufacturing

(c) Business of all categories

(d) The Services (Military)

(e) The Government (Civil) Service

(f) Transport and Public Utilities

(g) Constructional work

(h) Fisheries

(i) Mining

(iii) Though the economy of Japan is highly developed, how do you account for the fact that more people are engaged in agricultural pursuits than in manufacturing?

(iv) Japan has always topped the world's fisheries with the highest catches. Why, then, is such a small percentage of the employed engaged in the fishing industry? Does this give some indications of fishing methods?

(v) Of the 47 million employed, is the number of persons engaged in mining significantly large or small? Why?

(vi) Generally speaking, does the number of persons employed in the mining industries necessarily indicate a country's mineral resources?

(vii) Which kind of industry (from the list (a) to (i)) do you think is most likely to have frequent fluctuations in employment, and why does this state of affairs exist?

(viii) A little less than half of the 47 million persons employed are engaged in commerce and manufacturing. Does this information tell you that Japan is a great trading nation?

QUESTION 4.

The following shows the value of certain classified imports to Great Britain in a pre-war year, showing the sources of the commodities:

| | £ millions | |
	Foreign	Empire and Commonwealth
Bacon and ham	34·6	1·7
Frozen beef	4·9	1·9
Chilled beef	20·1	—
Butter and cheese	25·9	29·4
Wheat and flour	18·0	16·4
Barley, oats, maize	14·6	1·4
Eggs	13·3	3·3
Apples	4·3	3·6
Other fresh fruit	5·5	2·2

(a) Use diagrams to compare the sources of the imports of (i) meat and meat products, (ii) cereals and cereal products, (iii) dairy produce.

(b) Select one of the foreign cereals and one of the Empire–Commonwealth fruits, and for each describe the conditions under which it is produced in a specific region.

QUESTION 5.

The following Table shows the Imports and Exports of New Zealand for 1960:

	Imports %	Exports %
United Kingdom	53	44
Australia	5	18
Canada	2	3
Other Commonwealth countries	2	8
United States of America	13	10
France	7	2
Other foreign countries	38	27

(a) Total up the Imports and the Exports columns. Does it show that the Balance of Trade of New Zealand is (i) favourable or (ii) unfavourable? If a country imports more than what it exports (the value being in monetary units) does it show a country is getting on quite well, or rather the contrary?

(b) Using a radius of 2·5 inches, construct pie graphs to show separately the imports and exports of New Zealand for 1960.

(c) Construct bar graphs with positive values for exports and negative values for imports of New Zealand for 1960.

QUESTION 6.

The following temperatures show the weather conditions in each of the following cities at 12 noon, G.M.T. on 22 August, 1962:

Ottawa (foggy)	50°F.	Manchester (cloudy)	59°F.
New York (sunny)	68°F.	Paris (cloudy)	68°F.
Athens (sunny)	86°F.	Amsterdam (rainy)	59°F.

(a) Use a suitable scale to represent the temperatures in a column diagram. Print the cities and their respective weather conditions.

(b) Suggest a reason to explain the difference in temperature between Ottawa and Athens.

(c) Which of the above cities have (i) a cool temperate oceanic climate, and (ii) a Mediterranean climate?

(d) Which of the above cities are also the administrative capitals of their respective countries?

(e) Ottawa is situated at $45\frac{1}{2}°$N., whereas New York is at $40\frac{1}{2}°$N. The difference in latitude is only 5°, but the noon temperature in New York is 18°F. higher than Ottawa on 22 August 1962. Suggest reasons to account for the great temperature range between Ottawa and New York.

QUESTION 7.

The statistics below show the percentage of the world's output of hydro-electric power (excluding the Communist countries) produced by the countries named.

Country	Percentage of World Output
U.S.A.	32
Canada	18
Japan	12
Italy	7

Country	Percentage of World Output
Norway	6
Sweden	6
France	5
Switzerland	4
Germany	3
Others—excepting Communist countries	7

Associated Examining Board (G.C.E.) 1964.

(a) Represent these statistics diagrammatically.

(b) Summarize the factors that favour the production of hydroelectric power in each of the first five countries named.

QUESTION 8.

BRITAIN'S TRADE WITH SELECTED AFRICAN COUNTRIES

Country	Imports from Britain % Total			Exports to Britain % Total		
	1964	1965	1966	1964	1965	1966
Nigeria	28	30·9	30	41·3	37	37
Ghana	27	25·8	28·9	23	20	24·8
Sierra Leone	38	34·2	28·3	78	65	58
Kenya	33·4	28	33·6	22·3	21·3	21·7
Uganda	35·8	38·4	36	29	16·8	18·3
Tanzania	36·8	n.a.	n.a.	36·7	n.a.	n.a.

(n.a. = not available)

Illustrate these figures and say why you have chosen the particular method you use.

QUESTION 9.

Illustrate the following temperature and rainfall statistics, using the same scales throughout (Normal type—Temperature in Degrees F. *Italic type*—Rainfall in inches).

Station	Jan.	Feb.	Mar.	Ap.	May	Ju.	Jly.	Aug.	Sep.	Oct.	Nov.	Dec.
1 Altitude 50 feet	80 *1*	80 *1*	82 *2¼*	81 *8*	78 *14*	77 *3½*	75 *3½*	76 *2*	77 *2*	78 *3½*	79 *5*	80 *2*
2 Altitude 8,000 feet	59 *½*	62 *½*	64 *3*	61 *3*	63 *2½*	59 *6*	56 *11*	58 *12*	59 *7*	60 *½*	61 *½*	60 *0*
3 Altitude 20 feet	78 *1*	80 *1¼*	81 *1¾*	81 *3½*	80 *4½*	78 *6*	75 *1¼*	79 *½*	77 *1*	76 *2¼*	79 *1½*	79 *¾*

These stations are in Africa.

Having drawn the graphs for temperature and rainfall:
(a) Suggest locations for these stations. Give full reasons.

(b) What kind of natural vegetation will exist in these areas?

(c) Name likely farming crops.

QUESTION 10.

DIRECTION OF EXTERNAL COMMERICAL AIR TRAFFIC,
JANUARY–DECEMBER 1968

	A			B		
	Arrivals			*Departures*		
Place of origin/ destination	*Nairobi*	*Dar-es Salaam*	*Entebbe*	*Nairobi*	*Dar-es Salaam*	*Entebbe*
United Kingdom	49,300	8,000	10,500	61,000	3,000	10,000
Continental Europe	23,500	4,000	6,000	27,000	3,000	7,000
Middle East (including Egypt)	6,000	1,500	1,500	11,000	2,500	1,500
Arabian Peninsula, India and Pakistan	19,500	1,500	1,000	19,500	500	1,000
Africa North of Equator (excluding Egypt)	33,000	10,000	3,000	31,000	11,000	2,500
Africa South of Equator and adjoining islands	4,000	10,500	3,000	31,000	11,000	2,000
Others	4,000	1,500	1,500	4,000	500	1,000
Totals	139,800	37,500	26,500	184,500	31,500	25,000

(The figures refer to the number of passengers, not flights, and have been approximated for convenience. Note this table excludes movements within East Africa.)

Using world maps, draw flow-lines to illustrate these figures. Draw one map for Arrivals and another for Departures (remember the totals).

QUESTION 11.

ESTIMATED POPULATION BY RACE AND COUNTRY
(Figures in thousands)

East Africa	African	Non-African	Total	Analysis of Non-African			
				European	Indo-Pakistani	Arab	Others
1948	17,529	273	17,802	46	184	37	7
1962	25,559	506	26,065	89	345	61	11
1963	26,241	511	26,752	84	352	63	11
1964	26,944	510	27,454	78	357	64	12
1965	27,673	500	28,173	67	358	65	10
1966	28,417	505	28,922	67	361	66	10

(a) Draw diagrams to illustrate these figures. (Keep the analysis of non-African separate.)

(b) Why is there an apparent steady increase in the African population?

(c) Why is there irregularity in the other totals?

QUESTION 12.

EAST AFRICA: AREA AND POPULATION DENSITY

	Land Area (thousand sq. miles)	Water and Swamp (thousand sq. miles)	Total Area (thousand sq. miles)	Population Density (1968 per sq. mile of Land Area)
Kenya	220	5	225	45
Tanzania (mainland)	341	21	362	36
Zanzibar	1	—	1	360
Uganda	75	16	91	108

(a) Illustrate these figures and give reasons for your choice of method.

(b) Explain the variations in population density.

(c) Why is it necessary to have a column entitled 'Water and Swamp'?